LITTLE BOOK OF

Vivienne Westwood

This book is a publication of Welbeck Non-Fiction Limited, part of Welbeck Publishing Group Limited and has not been licensed, approved, sponsored, or endorsed by any person or entity. Any trademark, company name, brand name, registered name and logo are the property of their respected owners and used in this book for reference and review purpose only.

Published in 2023 by Welbeck
An imprint of the Welbeck Publishing Group
Offices in: London – 20 Mortimer Street, London W1T 3JW &
Sydney – Level 17, 207 Kent St, Sydney NSW 2000 Australia
www.welbeckpublishing.com

A CIP catalogue for this book is available from the British Library.

ISBN 978-1-80279-645-2

Printed in China

10 9 8 7 6 5 4 3 2 1

LITTLE BOOK OF

Vivienne Westwood

The story of the iconic designer

GLENYS JOHNSON

WELBECK

Contents

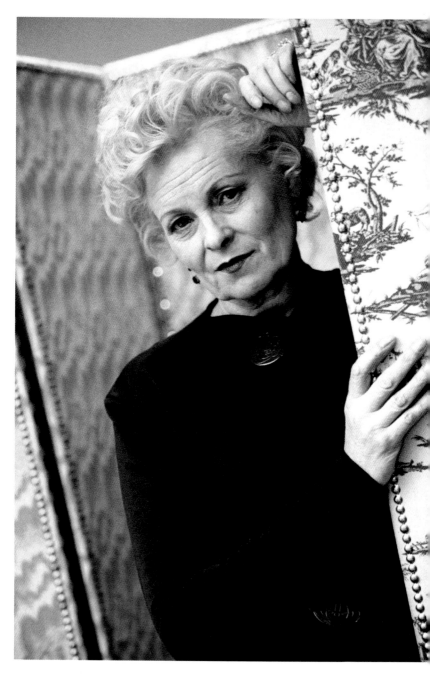

Introduction

"You have a more interesting life if you
wear impressive clothes."
Vivienne Westwood

Credited with being one of the most influential designers
and figures to come out of the UK in the twentieth
century, Vivienne Westwood played a key role in some of the
most pivotal movements of the era. From heading one of the
labels and destinations that promoted the punk movement
of the 1970s to, later, helping to spearhead a shift towards
more sustainable practices in the fashion industry across the
globe, Westwood was a woman with a passion for pushing the
envelope and challenging the status quo in the name of creating
a more just world – and ensuring we had plenty of show-
stopping styles to do it with.

OPPOSITE Alongside her statement designs on the runway, Westwood
was also known for wearing bold looks herself, among them was her bright
orange hair which she sported for much of her career, as pictured here.

OPPOSITE
Westwood poses
at Waterloo station
following the launch
of the Save the Arctic
campaign, July 2015.

BELOW
Photographer John
Stoddart captures a
smiling Westwood in
February 1991.

Westwood's immeasurable impact can be felt through her influence on fellow fashion names such as Alexander McQueen, John Galliano and Marc Jacobs, while fashion school graduates also continue to cite her as a key inspiration for their collections. As we explore the colourful life of the Derbyshire-born icon, we reflect on the power that one working-class ex-school teacher can have on the world of fashion, activism and culture as a whole – and all the ways in which her legacy continues to thrive after her passing.

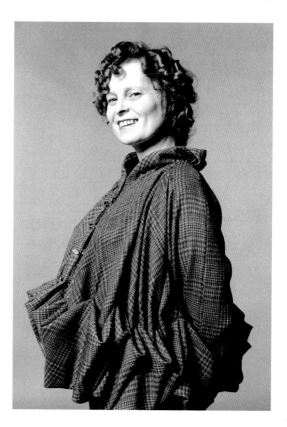

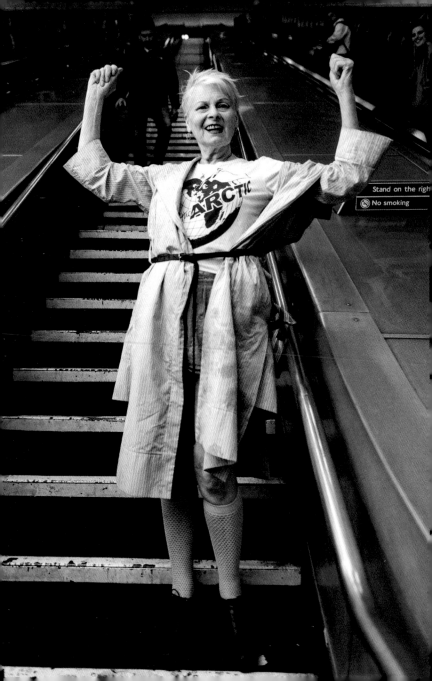

Early Years

MIDDLESEX COUNTY COUNCIL EDUCATION COMMITTEE

1949-50
HARROW
SCHOOL *of* ART

PROSPECTUS

HARROW TECHNICAL COLLEGE AND SCHOOL OF ART
STATION ROAD HARROW

Telephone Harrow 4211 (2 lines)

Origins of an Icon

"I've always felt heroic about my life... As a child, I remember little girls in the playground moaning about how boys could do more than they could. I didn't think that was the case at all. My parents didn't treat me as a girl."

Vivienne Westwood

The child of a weaver mother and grocer father, the icon we know as Vivienne Westwood was born Vivienne Isabel Swire on April 8, 1941, in Glossop, England. In the late 1950s, Vivienne and her family moved down to North London, where her parents ran a post office. Dora Swire would spend much of her spare time crafting clothes for Vivienne and her brother, Gordon. "My mother was very particular about clothes and what she'd let me wear," Vivienne once said. "She made it all."

When reflecting on her childhood, Vivienne noted: "I lived in a part of the country that had grown up in the Industrial Revolution." She added: "I didn't know about art galleries . . . I'd never seen an art book, never been to the theatre."

OPPOSITE Westwood attended Harrow School of Art for one term before leaving to attend teacher training college.

Vivienne began crafting her own clothes at a young age, making dresses for herself while still at school. She continued creating into her late teens when she enrolled at Harrow School of Art. It wouldn't take long for her to leave the course, feeling isolated from her peers due to her working-class background. She would instead enrol at teacher training college and go on to teach at primary school, making jewellery in her spare time and selling it from a stall at Portobello Road Market.

In 1962, Vivienne married a man named Derek Westwood, whose name she would keep until her death in 2022. Derek was a tradesman and a proud Mod, a subculture that swept the UK for much of the 1960s. The pair welcomed a son, Ben, into

the world the next year, parting ways just months later. Now in her mid-twenties, Vivienne left Derek and took their baby son to live with her parents, and worked on her jewellery projects to make a living.

While attending art school, Vivienne's brother Gordon crossed paths with a 19-year-old character known as Red Malcolm. Gordon and his new friend rented a flat together and soon invited Vivienne and baby Ben into the home. Following a whirlwind courtship, Vivienne and Malcolm welcomed their own son, Joe, into the world.

Malcolm McLaren's family was familiar with the fashion game. His mother and stepfather ran the womenswear label Eve Edwards, while his grandfather was a Savile Row tailor. Paul Gorman, one of the curators behind the 2014 exhibition 'Let it Rock: The Look Of Music The Sound Of Fashion', exploring McLaren's contributions to fashion, stated, "He also quickly realised the potency of popular music and fashion. Once you put the two together you get some kind of combustion."

Malcolm became a key figure in Vivienne's life, infusing influences of groups like King Mob and ideologies from the Situationists, a European group of social revolutionaries who sought to challenge capitalist ideals. His presence stoked a fire in Vivienne, already very much a rebel in her own right, and inspired a newfound dedication to the world of clothing and its use to communicate messages of rebellion, revolution and resistance.

Vivienne and Malcolm, both individually and as a pair, would go on to pave new paths – through the subcultures developing in the UK and, ultimately, across the wider fashion world.

OVERLEAF
Westwood left teaching in 1972 to pursue creative activities full-time with Malcolm McLaren. The duo are pictured here in 1976 outside Bow Street Magistrates' Court, where McLaren was remanded on bail for fighting.

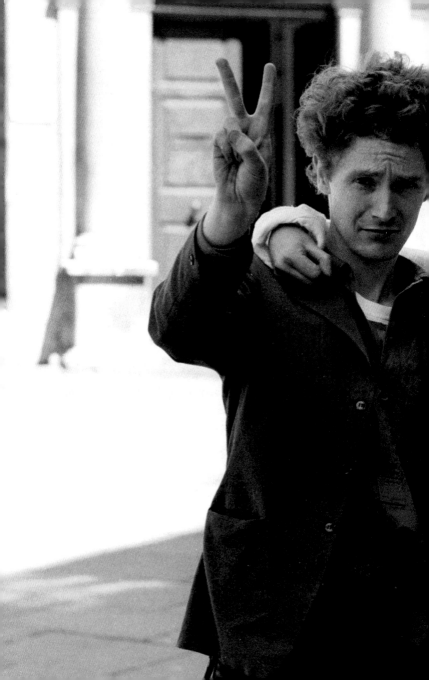

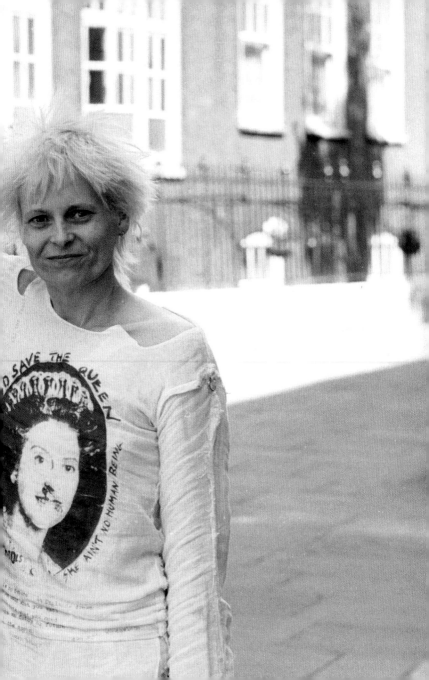

Punk is Born

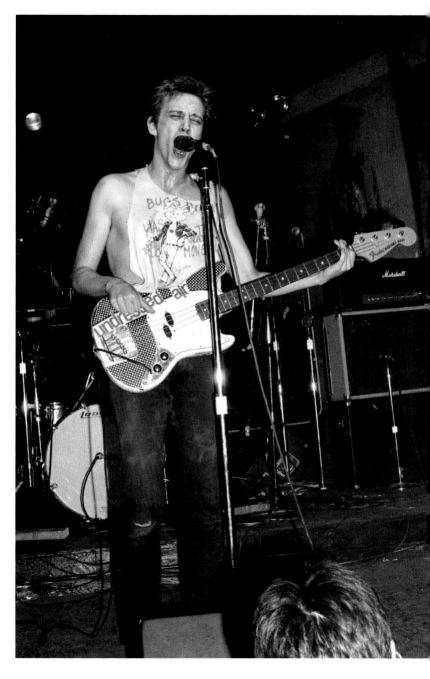

The Birth of Rebellion

"It was about smashing all of the values . . . all the taboos of a world that was so cruel and unjust, mismanaged and corrupt."
Vivienne Westwood

How "punk" as we know it today came to be is a topic as contentious as the subculture itself. But what we can agree on is that a particular drinking establishment in NYC's East Village by the name CBGB was the early stage for many of the most iconic punk bands of the 1970s. This would be the place where Malcolm McLaren would witness Richard Hell and the Voidoids perform in 1975, inspiring him to switch lanes once back in the UK and to put much of his energy into recreating what he witnessed across the pond. Vivienne's rebellious nature was always looking for a way to be expressed, and as Malcolm began spending day and night immersing himself in this new underground movement, Vivienne's fascination also grew.

OPPOSITE Richard Hell and the Voidoids are noted as a key influence behind McLaren's drive to bring the rough approach (later dubbed as "punk") to the UK. Hell is pictured here performing at CBGB in 1978.

"It is impossible to define punk. It is subjective and means something different to everyone . . . [it is] exciting, confusing, exhilarating, an unpinned grenade, intellectual but not academic, revolutionary. It tore a hole in the fabric of pop culture and we all got through."
– John Robb, musician and punk vocalist

Though their relationship would come to be a very unhealthy one, Vivienne would credit Malcolm with playing a key role in infusing her into the subcultural scene, telling the *New York Times* in 1999, "I latched onto Malcolm as somebody who opened doors for me, I mean, he seemed to know everything I needed at the time."

The punk movement in the UK could partially be credited to a palpable period of conflict caused by the stark economic issues of the time, the widening of the gap in values of the main political parties and the increase in violence across Great Britain (notably the Troubles in Northern Ireland, of course). Mix these issues with the oversaturation of the airwaves with the glam rock groups of the decade and, arguably, you've got the perfect environment for a dirty, gritty movement like punk to flourish. And that's exactly what it did. And at its heart were Westwood and McLaren.

"I was about 36 when punk happened and I was upset about what was going on in the world," Westwood explained in an interview with *Harper's Bazaar*. "It was the hippies who taught my generation about politics, and that's what I cared about – the world being so corrupt and mismanaged, people suffering, wars, all these terrible things."

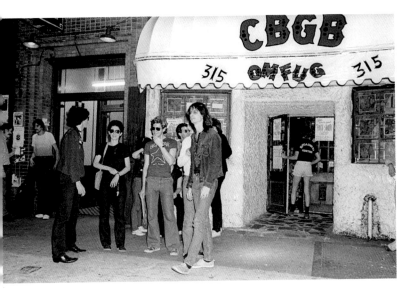

The couple would channel their anti-establishment mentality into various ventures over the next decade or so, ultimately playing a key role in changing the cultural landscape when it came to UK music and fashion.

Viv Albertine, the frontwoman of iconic band the Slits, described in her 2014 memoir how McLaren and Westwood used many of their early apparel designs as a way to not only shock and provoke the general public but also how it could be used to amplify the message behind early punk music. By lining the shelves of the King's Road shop with exposed stitch styles, slashed T-shirts and loosely-knit mohair jumpers that appeared to be nearly falling apart, the duo showed they weren't afraid to expose the constructions of their creations in this way. Albertine argues that this promoted one of the key messages behind the punk movement, that it's "OK not to be perfect, to show the workings of your life and your mind in your songs and your clothes."

ABOVE The iconic CBGB opened in 1973 and would act as a key venue for acts like the Ramones, Talking Heads and Blondie.

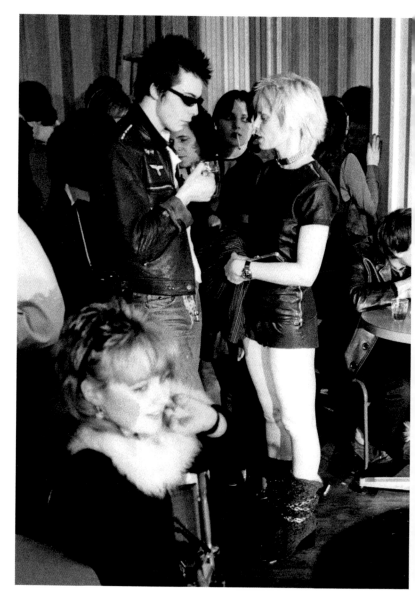

THE SHOP ON THE KING'S ROAD

In 1971, Vivienne and Malcom rented a space in the back of a shop on the King's Road. This is noted as the birthplace of their retail venture, or the testing ground for much of their creative outputs – from vinyl records to graphic T-shirts to avant-garde latex outfits.

Let it Rock was the first title of the space. McLaren told the *New Yorker* in 1997, "We set out to make an environment where we could truthfully run wild. The shop rarely opened until eight in the evening, and for no more than two hours a day. More important, we tried to sell nothing at all. Finally, we agreed that it was our intention to fail in business and to

OPPOSITE Sid Vicious, bass player for the Sex Pistols, and Vivienne Westwood at the Notre Dame Hall in London's Leicester Square in November 1976.

BELOW Malcolm McLaren is often referred to as the Godfather of Punk, credited with managing the Sex Pistols and the New York Dolls, among others. He is pictured here at the EMI offices in Manchester in 1976.

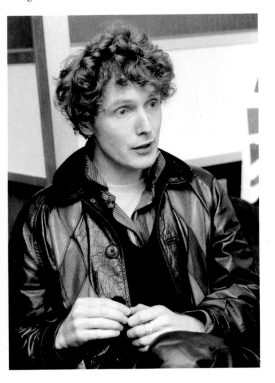

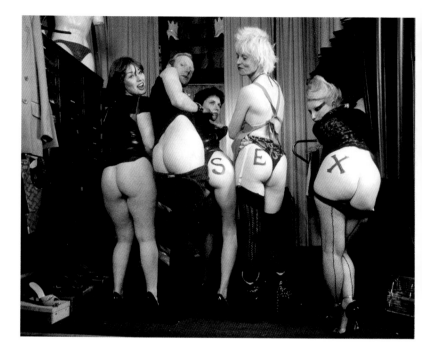

ABOVE Vivienne and the staff of SEX pose for a cheeky shot inside the King's Road boutique.

fail as flamboyantly as possible, and only if we failed in a truly fabulous fashion would we ever have a chance of succeeding."

Next up was a short stint as Too Fast To Live, Too Young To Die, a space focused on motorcycle jackets and skinny black jeans akin to the style that bands like the Ramones lived in across the Atlantic. Teddy Boys would still get their fix of Edwardian-inspired looks from the Let it Rock label that bled through from Westwood and McLaren's Americana looks of the previous years. It was under the Too Fast To Live, Too Young To Die moniker that Vivienne began crafting T-shirts with messages inspired by anarchistic figures and movements ("SCUM" sprawled across one design in chicken bones references the 1967 manifesto by Valerie Solanas).

But it was the years that the shop sat under the SEX and Seditionaries names that made the biggest impact on the King's Road history. With its brash disregard for all things "proper", the shop captured the attention of young people across the country (punk was not a term widely used at that point). The space acted as something of an incubator for what many argue is one of the most influential subcultures in history – both for its aesthetic impact and disruption of the status quo. "I wanted to sell things that were normally sold in brown paper bags under the table. I tracked down manufacturers all over the UK . . . black rubber T-shirts, black rubber raincoats, tit clamps, and cock rings. We sold it all," said McLaren about the store in its SEX era. In 1979, the final name change would occur with its adoption of the title Worlds End, which it still holds in 2023.

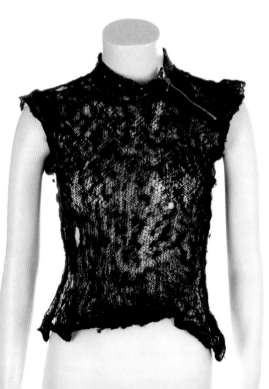

LEFT Westwood and McLaren's early designs included this 1975 mohair top that featured a diagonal zip collar and label that read "SEX original".

In a 2014 interview with *i-D*, Westwood stated the importance of the shop, "Worlds End has always been a crucible for my ideas, political and cultural. Its timeless fashion. We recycle fabrics and cuts and sell them for the best price possible in order to be affordable to as many people as possible."

REBELLION HITS THE CHARTS

In 1974, McLaren began managing a group, then called the Strand. It was made up of three working-class youths who were keen to challenge authority and push boundaries. McLaren quickly encouraged Glenn Matlock, one of the workers at the King's Road shop, to join as a bassist before completing the group with John Lydon in 1975.

The group became a key player in the UK punk scene, wearing clothing almost exclusively made by Vivienne, including distressed muslin tops adorned with the face of Queen Elizabeth II. By this point, the shop had rebranded as a destination for fetishwear and taken on the name SEX, though it quickly took on its next moniker, Seditionaries.

For a period, the Sex Pistols were a calling card for Vivienne's designs, and key in helping introduce the masses to the punk sensibilities and anarchistic outlook that the younger generation at the time was so desperate to embrace.

KEY CHARACTERS

Beyond the ever-changing names and merch, the King's Road shop employed some of the most influential characters on the UK punk scene at the time. First there was Jordan – no second name needed. The blonde, Seaford-born rebel started work just after Westwood and McLaren changed the shop's name to SEX. She was famous for her provocative looks, which captured the attention of many and made her an

OPPOSITE Jordan, Westwood and friend are photographed in Westwood and McLaren's early designs, April 1977.

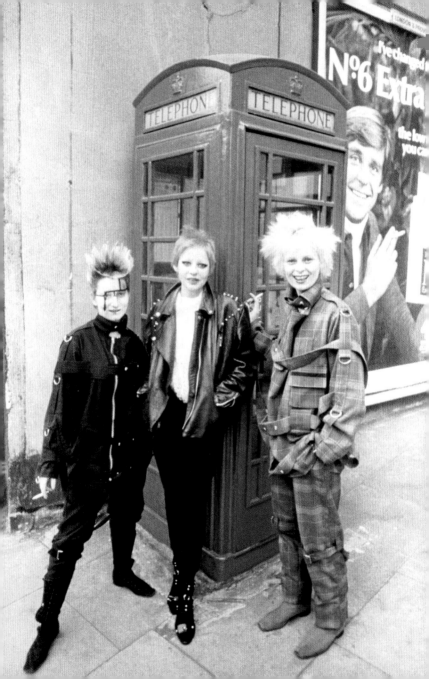

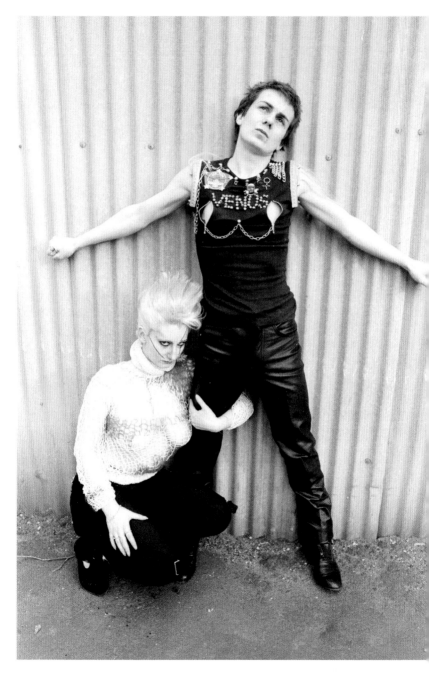

icon in the punk movement. She would go on to become a manager for Adam and the Ants and star in the leading role of the cult classic film *Jubilee*, depicting Derek Jarman's interpretation of the punk movement (criticized by Vivienne).

Chrissie Hynde also worked shifts at the King's Road spot, giving her a front-row seat to the forming of the Sex Pistols and forming bonds with the band that would last for decades. The frontwoman of the Pretenders would later reflect on her time working with Westwood and McLaren, saying: "I don't think punk would have happened without Vivienne and Malcolm . . . Something would have happened and it might have been called punk, but it wouldn't have looked the way it did."

Bella Freud and Alan Jones were also assistants at the shop, an experience that led to Jones being arrested at one point for public indecency after strolling down King's Road wearing a provocative Westwood T-shirt of two cowboys exposing their penises.

THE CLIENTELE

As the themes of the shop changed, so too did those who frequented it. When Westwood and McLaren initially obtained the space, their regulars were into the Teddy Boy style. But as things shifted, shoppers leaned away from the quiffs and towards the spiked styles and bold colours.

The Bromley Contingent was the name given to a group of young people who would frequent performances by the Sex Pistols and, in turn, the King's Road shop. Notable members of the group included Billy Idol, Siouxsie Sioux, Steven Severin and Soo Catwoman. This motley crew would come to be seen as one of the most influential groups when it came to popularizing the punk subculture in the UK.

OPPOSITE Jordan and Six (né Simon Barker) model clothes from Seditionaries in May 1977.

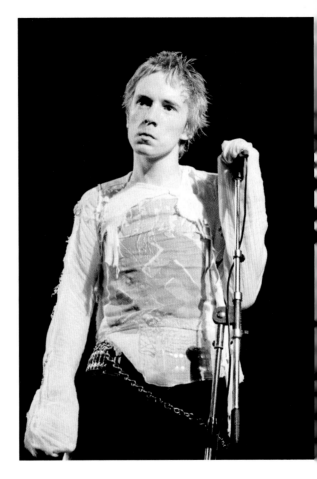

Soo Catwoman, in particular, played a key role in showcasing the rebellious look, sporting a colourful 'do characterized by spiked sides and a shaved centre. Her notoriety is proved by her mention in the 2000 punk documentary, *The Filth and the Fury*, where the Sex Pistols' Johnny Rotten notes, "It took style, skill, and bravery to look like a cat."

THE AESTHETIC

Though many who played critical roles in defining punk would be horrified at the term "the punk look", the reality is undeniable – the movement did create a uniform.

As Westwood, McLaren and co were challenging the status quo and pushing boundaries across the board, they were playing a key role in forming the punk aesthetic – one that continues to be instantly recognizable to this day.

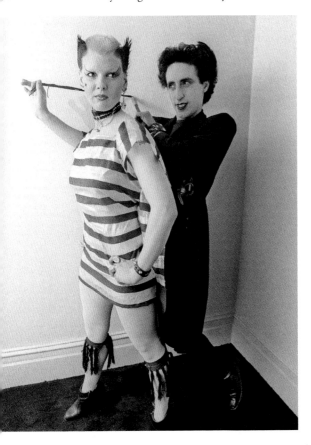

LEFT Soo Catwoman (legal name Susan Lucas) and Philip Salon were key characters present at the King's Road shop, pictured here in 1976.

ABOVE Siouxsie Sioux, Philip Salon, Debbie Juvenile, Simon Barker, Steve Severin, Berlin, Soo Severin, Sharon Hayman and Linda Ashby were dubbed "The Bromley Contingent", pictured here in October, 1976.

As Scottie Andrew, CNN culture journalist, highlights, "Westwood's clothes during this era were intentionally challenging and abrasive, made to comment on conservative ideals and a lack of social progress. She was influenced by leather-clad bikers and pinup girls of the 1950s, the bondage-heavy S&M subculture with its hardware and a DIY ingenuity – safety pins, zippers, haphazard hems – coupled with traditional fabrics like tartan."

As much of the original message behind punk makes clear, the clothing also took on a transgressive approach, breaking

things down in the hopes that what would be rebuilt would stand stronger than the original. "The punk look has come to be associated with clothing that has been destroyed, has been put back together, is inside out, is unfinished, or is deteriorating. Punk was an early manifestation of deconstructionist fashion, which is an important component of late twentieth-century postmodern style and continues to be seen in the work of contemporary fashion designers," said Shannon Price of the Metropolitan Museum of Art in 2000.

VIVIENNE MOVES ON

Though often noted as a key player in the movement (in the UK, at least), Vivienne's relationship with punk wasn't without its complications.

In 2013, Westwood reflected on the punk era and her role in it, telling *Harper's Bazaar*, "Punk folded when the Sex Pistols folded and Sid [Vicious] died . . . I realized that the kids who were interested in it were interested because of the way it looked. They all went on to do other things, and I don't think any of them had any politics. They just liked having a good time. Others went on to make their whole life around it. There are punk pundits, and Johnny Rotten is still doing his act. I thought highly of Johnny at the time, but to just carry on being 'Johnny Rotten' on a kind of pedestal as 'the token rebel' . . ."

Westwood believed that punk, like many subcultural movements over time, had lost its essence. The message that the movement stood for in its early years became diluted – in part, ironically, due to the appeal of her own shop and clothing. As the BBC noted in its obituary of Westwood:

"The clothes and music were supposed to channel rage and bring about change. But the young simply ignored global injustice, stuck safety-pins in their nose and moshed

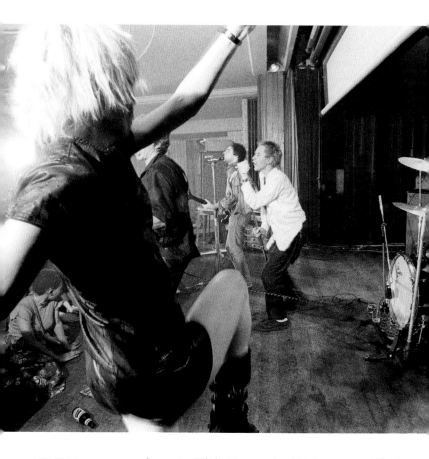

to the music. While Westwood and McLaren were full of
revolution, it never happened. Westwood felt let-down, became
disillusioned and, eventually, drifted on."

Though Vivienne would never stray too far from her anti-
establishment approach, her horizons would soon expand,
taking her beyond spiky hair or chicken bone tops and into
new realms, ready to reimagine the institutions she had
previously extensively rejected.

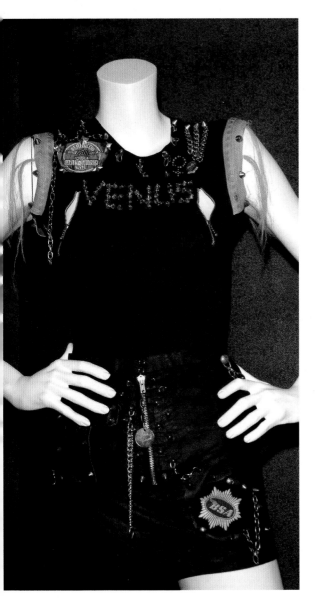

LEFT The original Venus T-shirt appeared in 1971, during the period of Westwood and McLaren's Let it Rock shop. Here, it sits on display at the Victoria and Albert Museum as part of a 2004 exhibition.

Moving into New (Romantic) Realms

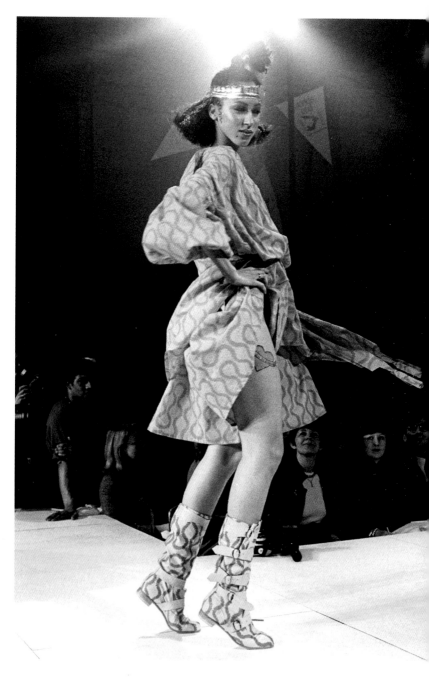

New Directions

"Punk in turn kick-started an explosion of subcultural research
. . . the Mod Revival of 1979, the Ska revival, and the onset of
the New Romantics, who freely and gleefully plundered
styles going right back to the nineteenth century.
Clothes became more than individual adornment:
a matter of deep, tribal identification."
Jon Savage

By the late 70s, Vivienne's dedication to punk was dwindling. Once an outlet for challenging the establishment, her designs were now morphing into a vessel for exploring and distorting the concept of class, historical narratives and national identity.

In a 2016 article in the *New York Times*, Alan Riding summarized this shift, "As her career turned respectable, she was also drawn toward beauty. She initially retained some punk symbols, like ripped and cut cloth. She also introduced lasting novelties, endlessly copied, like bras worn outside

OPPOSITE A model poses on the catwalk wearing the infamous pirate boots, adorned with the soon-to-be famous "squiggle" print, 1981.

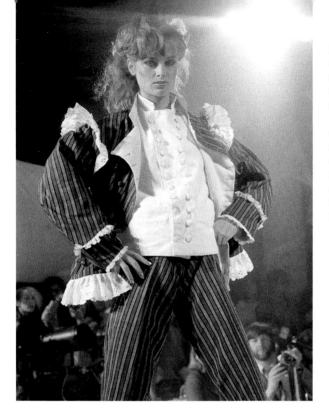

dresses, multiple straps and suspenders, baggy diaperlike shorts, bare midriffs and corsets. But it was her evocation and reinterpretation of historical costumes, often inspired by 18th-century paintings, that would become her trademark."

The New Romantic movement was all about reimagining the Romantic period of the late 1800s and early 1900s, while infusing bold elements from the bygone 70s glam rock scene. Think petticoats, bold make-up, feathered hair, dramatic draping and the almighty frilly shirt. Key players in the scene included Adam Ant, Boy George, Steve Strange and later on, David Bowie.

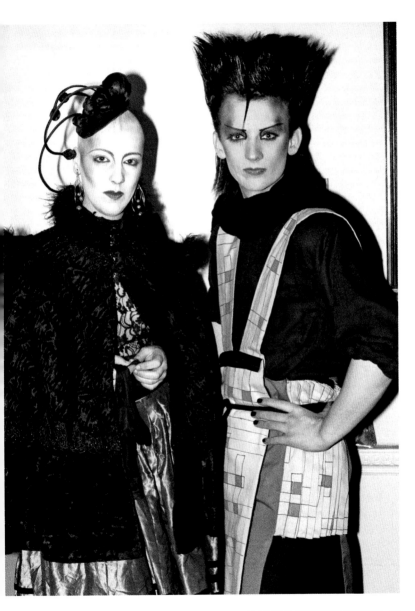

"We just spent 10 years re-assimilating the 30s through the 70s," said Westwood at the time. "The 80s will be a technological age for which we need to equip ourselves with a feeling of human warmth from past ages – of culture taken from the time of pirates and Louis XIV."

In his autobiography, *Take It Like a Man*, Boy George explained that he felt punk around this time had lost its meaning and become a parody of itself. The scene began to attract those who were looking for an outlet for aggression and would target those who, like Boy George, opted for make-up and frills rather than the punk uniform that had developed.

RIGHT Adam Ant and Jordan backstage at the Roxy Club in 1977.

OPPOSITE Boy George and Steve Strange played a key role in the New Romantic scene in London, pictured here adorned in their trademark styles at an event they ran together in the 1980s.

The New Romantics scene came alive in clubs across Birmingham and London. Most would agree it started at Billy's in Soho before moving to the Blitz Club in London's Covent Garden district. Led by a group nicknamed the Blitz Kids, the community gathered around nights run by characters like Steve Strange and Rusty Egan, promoting one of the strictest door policies in town. What got you in? Well, that was totally up to who was on the door. Mick Jagger himself was reportedly turned away when attempting to get a piece of the action.

"We're making people realize that Britain has got something happening again which has been missing, I think anyway," said Blitz host and Visage singer Steve Strange in 1982.

THE PIRATE COLLECTION

Though having designed clothes and played with jewellery design for years by then, Vivienne is noted as saying that her fashion career truly began in 1981 with the Pirate collection.

"She came from this anti-fashion stance to then wanting to become a fashion designer but still bring that subversive edge with her," says Valerie Steele, director of the Fashion Institute of Technology.

This collection marked the first of Malcolm and Vivienne's to be presented on a runway. The influences behind the collection range from eighteenth-century dandies to the wardrobe of the Michael Caine film *The Island*, a film about a group of pirates, released the previous year. In the mix were billowing tunics, slouchy leather jackets complete with fringe trim and, of course, felt Admiral hats.

This collection is not only credited for introducing Vivienne to the catwalk, but was also the platform for what would

BELOW Wearing various pieces from Westwood and McLaren's Pirate collection, New Wave's Bow Wow Wow smile for the camera in November 1981.

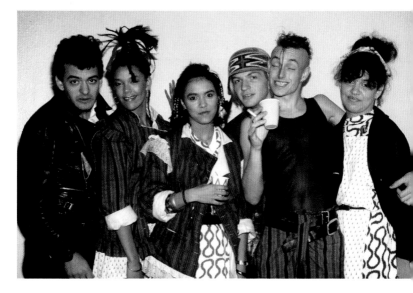

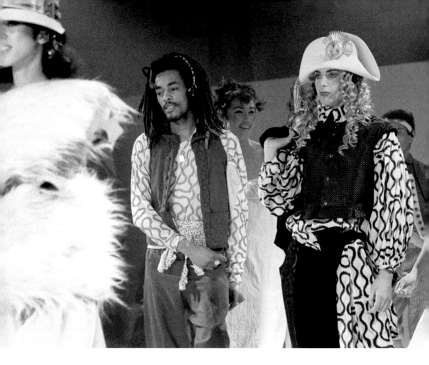

go on to become one of her most recognized prints – the "squiggle" print. The realization of the print as we know it today is rumoured to have occurred when Vivienne attempted to sketch out a rope-inspired motif. The print was sprawled across many of the collection's key pieces and displayed on the backs of some of the key musical acts associated with the New Romantics, including Adam and the Ants and Bow Wow Wow.

Photographer Michael Costiff, who was in attendance at the Pirate runway show presentation, told the *Financial Times* in 2011, "It was such a grey time in London, and the show had so much colour, with the orange squiggle prints, gold lipstick and multi-racial models appearing through the smoke to a Burundi soundtrack. It was all so unexpected after punk. We couldn't wait to go shopping."

ABOVE Models flaunt the Worlds End Pirate collection on the catwalk in October 1981.

OVERLEAF Westwood styles Bow Wow Wow lead singer Annabella Lwin for a studio shoot in London, 1980.

THE SOUNDTRACK OF A MOVEMENT

Just as the duo used the Sex Pistols as a calling card for their earlier clothing designs, Vivienne and Malcolm sourced some of the 80s most subversive musical acts to model their recent collections. In 1980, Adam Ant commissioned Malcolm McLaren to manage the band in the hopes he'd bring them to new heights as he'd done for the Sex Pistols a few years earlier. What ended up happening was that Malcolm stole Adam's band to form his own group, Bow Wow Wow – a group dedicated to modelling Westwood and McLaren's first few collections, beginning with Witches.

Many see the formation of Bow Wow Wow as a clear ploy by Malcolm to have a platform to promote the duo's collections and solidify the New Romantics movement – on the back (quite literally) of the attention received by the band and its 13-year-old lead singer, Annabella Lwin. The group would go on to become one of the more iconic music acts of the New Romantics era and release hits like 'C.30, C.60, C.90, Go', 'Do You Wanna Hold Me?' and the classic 'I Want Candy', released in 1983. And McLaren's idea seemed to work. Fashion designer Marc Jacobs is noted as claiming he was very much influenced by Bow Wow Wow, telling *i-D* in 2023, "There was a guy in New York, one of the New York characters named Terry Doctor . . . I would always go back to Terry or whoever else saying, 'I need to get clothes from Pirates,' or, 'I need to get this top that Bow Wow Wow were wearing.'"

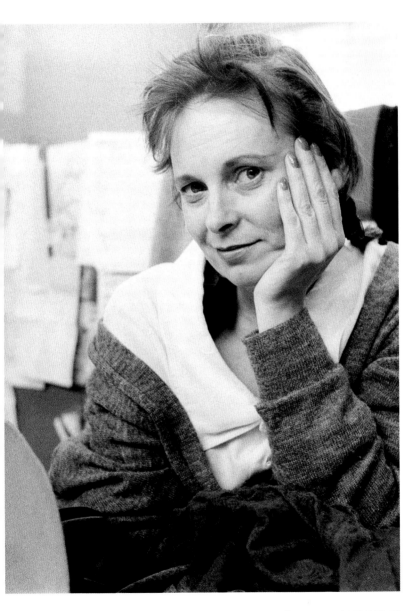

Becoming Vivienne

Creative Evolution

"Knowledge of the past lends perspective to the present
and insight into the future. All my ideas come from studying
the ideas of the past. I design clothes in the hope of
breaking convention."
Vivienne Westwood

The next few collections would go on to play with themes around Indigenous dress from countries afar and to rework the traditional cuts and motifs of various overseas cultures. The 1982 collection entitled Savages is also reported to have been inspired by the works of Matisse and Picasso, infusing the linework that partially defines their artwork into patterns across Westwood's dramatic cuts.

OPPOSITE Vivienne Westwood poses with crown and orb necklace as part of a 1987 photoshoot.

BELOW The Worlds
End Buffalo/
Nostalgia of Mud
collection is sported
by a group of models
as a part of a 1983
shoot.

BUFFALO/NOSTALGIA OF MUD A/W 1982

In 1982, the Buffalo/Nostalgia of Mud collection hit the
shelves, sitting under the duo's Worlds End label. Westwood
and McLaren took influences from Peruvian women and their
exaggerated bowler hats and "primitive" ways of dressing.
Garments took on varying shades of brown and some were cut
from raw sheepskin. This would also be the collection to launch
Westwood's habit of exploring underwear being presented as
outerwear, most notably with the satin bras of the collection,
styled atop wool tunics. The 50s-inspired piece featured leather
detailing, setting it apart from its lingerie counterparts. The
flowing skirts of the Peruvian women were recreated in natural
wool styles, accompanied by animal hide waistcoats with
toggle detailing.

Westwood and McLaren briefly rented a shop front for
the collection nearby London's Bond Street area, just a stone's
throw from the high-end department store Selfridges. The
storefront featured a world map, with the interior designed

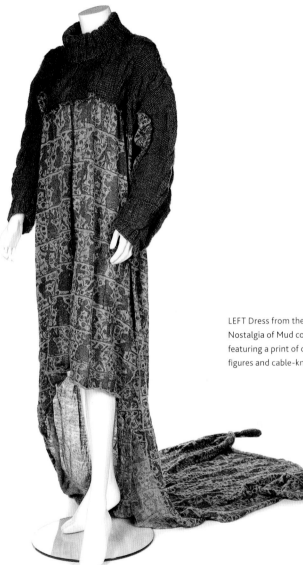

LEFT Dress from the Buffalo/Nostalgia of Mud collection, featuring a print of dancing figures and cable-knit upper.

OPPOSITE Popstar
Madonna is
photographed in a
knitted skirt from
Westwood and
McLaren's Witches
collection in 1984.

to look like an archaeological excavation site. Visitors saw the
"mud" pond surrounded by objects related to the practice of
voodoo, a notable interest of McLaren at the time.

But undoubtedly the key piece of the collection (and
arguably a peak of Westwood's entire career in fashion) was the
Buffalo Hat. The exaggerated size took the felt construction to
new heights and would come in and out of focus throughout
her career, and make appearances in McLaren's later ventures
into the world of hip-hop. But more on that later on.

WITCHES A/W 1983

The Witches collection also looked to the visual arts for
inspiration, this time working with designs from American
artist Keith Haring. Haring's work was defined by his use of
figures and symbols that offered commentary on various issues
prevalent in 80s New York and he is credited with introducing
popstar Madonna to the collection (she remains a fan of
Westwood designs to this day). Vivienne and Malcolm called
upon Keith to adorn their collection of knitwear and jersey
pieces, cut into Japanese-inspired cuts with statement shoulder
and tank dresses primed to be worn alongside the collection's
Jester-esque headwear.

Rebellion, sisterhood and feminism were themes coming
out of witch folklore and resonating with Westwood and
McLaren. The 1983 collection would introduce one of the
first of Westwood's reinventions of the classic trench coat. The
defining features included exaggerated, angular sleeves and a
pattern cut strictly into triangle pieces. This style would also
be carried over into the next season, making an appearance
at Hanae Mori's "Best of Five" global fashion awards, where
Westwood was a nominee alongside Calvin Klein, Claude
Montana and Gianfranco Ferré.

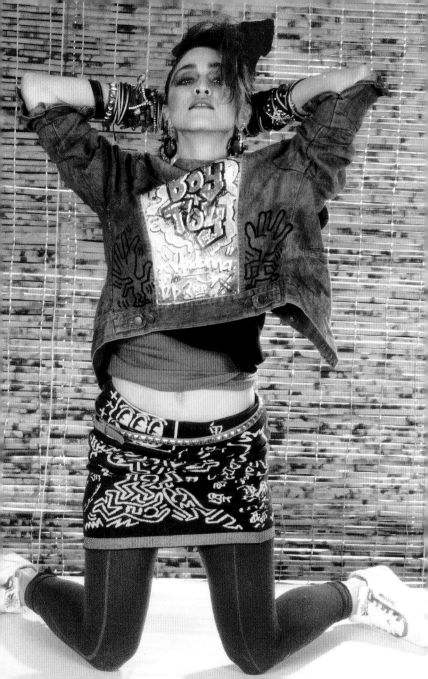

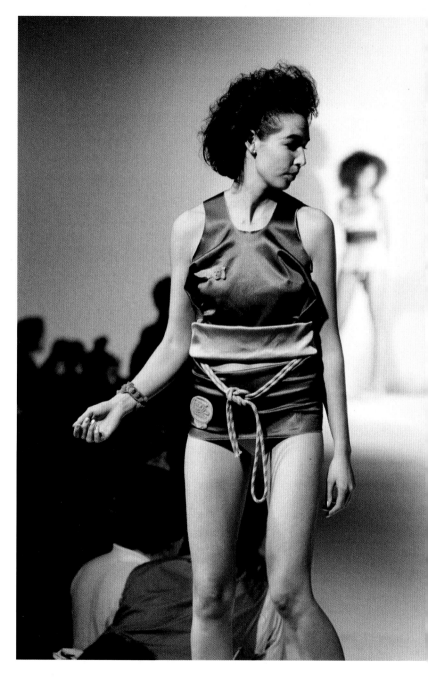

RIGHT The Hypnos
collection featured
penis-shaped toggles,
pictured here on one
of the collection's
jackets.

OPPOSITE A model
wears a one-piece
style from the Worlds
End 1984 Hypnos
collection.

HYPNOS S/S 1984

In 1984, as their professional relationship was disintegrating, Westwood and McLaren released their final collection under the Worlds End label, with the name Hypnos. Westwood took inspiration for the collection from football T-shirts that lined nearly every street in Britain at a time when football hooliganism was rife across the country. Westwood took a theme that was then seen as divisive and did what she did best – she ran with it. It was in this collection that she was able to secure her name in the hearts of another demographic in the media spotlight across the globe.

London in the 80s had become a haven for freedom of expression and the destination for round-the-clock parties, especially in Vauxhall and Soho, two of the capital's top spots for the gay community. The sexualized nature of Westwood's designs was welcomed with open arms by gay men looking to flaunt themselves and their sexual identities in a way that wasn't possible in the decades previous. And the fluorescent bodysuits complete with phallic buttons from the Hypnos collection were the perfect attire.

Murray Blewett, often seen as one of the original members of the Westwood crew, spoke of wearing the collection at the time, saying: "I wore those clothes all the way through and my favourite things were Hypnos, which is in '84, these sports things, funny all-in-ones. And that was really pushing the look, we used to wear them to Kinky Gerlinky, Taboo and Heaven."

CLINT EASTWOOD A/W 1985

Noted for being the first collection without the contribution of Malcolm McLaren, the Clint Eastwood collection would prove Westwood's talent as an individual and help her to set sail into the fashion world as a solo designer.

OPPOSITE A rare Vivienne Westwood outsized trench coat, from the Hypnos collection, S/S 1984.

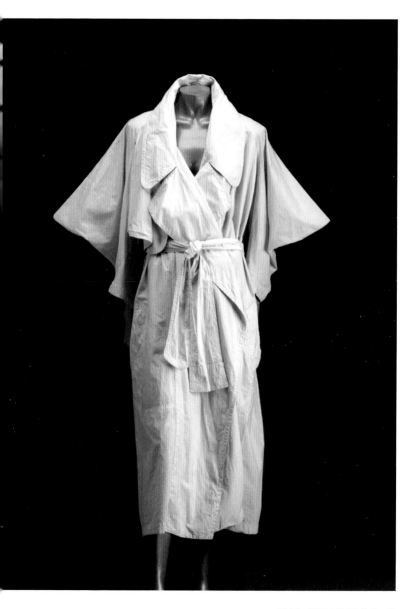

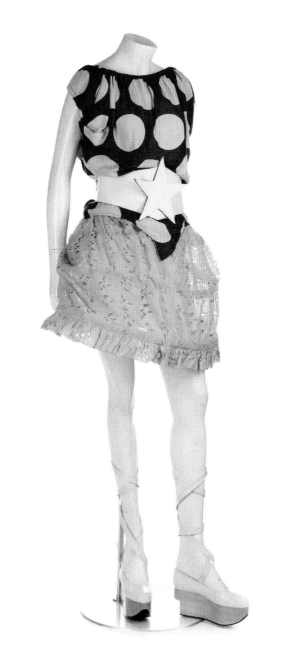

> "A world set apart. Wild big open spaces. Spaces where you have to be dependent on your own resources and are independent of anyone else's law. Something like life in the old Wild West, illustrated perfectly in spaghetti westerns & the western films of Clint Eastwood."
> – Murray Blewett on Worlds End, *HERO* magazine

By 1985, Westwood had become more comfortable with her role in reimagining garments that many wouldn't dream of touching. The Clint Eastwood collection saw an example of this confidence in one particular jacket, which would come to be known simply as the Clint Eastwood bomber. Westwood set out to create an outerwear piece that didn't follow any of the rules associated with anything on the market. Tearing apart the rule book, the result was a jacket without any curved lines and featuring balloon sleeves, abstract proportions and wool rib trims. The jacket would go on to be recreated in countless collections and be reimagined by various fashion designers for decades to come.

MINI CRINI S/S 1985

The 1985 Mini Crini collection often tops the lists of Westwood's most influential. With inspiration from *Petrushka*, a ballet burlesque, the collection featured hooped miniskirts referred to as "mini crinis", juxtaposed by bold, power shoulder blazers, Oh so 80s polka-dot prints and larger-than-life statement belts that emphasized the model's hips.

The mini crini combined the Victorian crinoline with the miniskirt of the nineteenth century, and is now indelibly associated with her.

OPPOSITE An outfit made from pieces from the Mini Crini collection, including the Gypsy blouse, mini crini skirt and white leather star belt.

Alongside it, the Rocking Horse heels would also go down in history as one of Westwood's most recognizable and repeated designs. Speaking of the design, Westwood said: "I wanted these little childish shoes, like sandals but a bit like clogs. They had to have a little platform – they rocked a bit. They were important in the collection." They were reportedly inspired by the traditional Japanese flip-flop style of footwear worn by geishas, made of wood and featuring heightened soles to prevent their kimonos from getting dirty.

Even decades later, the impact of this collection can still be felt on the runway, season after season. The dramatic mini crini cut can be seen across collections from the likes of Louis Vuitton, Dior, Loewe and Paco Rabanne.

THE ORB IS BORN

In the mid 80s, Westwood found herself seeking a hiatus from the lights of London, prompting her to head south to Italy, where she would spend time with her designer friend Elio Fiorucci and use his studio space to come up with fresh designs. It was in this space that she was inspired to create the motif that would become synonymous with her brand.

RIGHT The orb motif appears on many Westwood designs, from all-over prints to metal emblems like the one seen here.

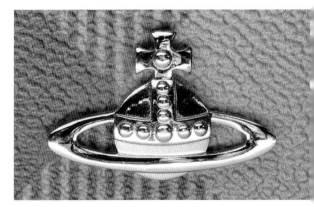

The story goes that Westwood was designing a knitwear piece that the then Prince Charles may choose to wear in his spare time. This idea led her to explore various patriarchal and royal symbols. That's when she landed on an orb surmounted by a cross. But having also been inspired by imagery from a set of astronomy books gifted to her by her young son, depicting the solar system in all its glory, she added a final touch – the rings. The pairing of the two symbols would represent both Westwood's appreciation for regal history (through the orb) and futuristic themes (through the rings), as pointed out at the time by Carlo D'Amario (now CEO of the Westwood brand).

Beginning with the Harris Tweed collection, the Westwood orb would become a staple in all the Westwood collections and feature on some of the most iconic of designs, including the Mini Bas Relief Choker (more on that phenomenon later on).

HARRIS TWEED A/W 1987

"She couldn't have been more than 14. She had a little plaited bun, a Harris Tweed jacket and a bag with a pair of ballet shoes in it. She looked so cool and composed, standing there," Westwood recalled in a 2011 interview with the *Independent*. And that chance sighting would inspire one of the designer's most famous collections.

Westwood's Harris Tweed collection took her further down the road of exploring traditional British materials and their significance in modern society. With a focus on bringing the particular type of tweed hailing from the Scottish Hebrides into fashion, the Harris Tweed collection offered a line-up of traditional tailoring fused with experimental cuts and nods to medieval styles like the corset.

The corset style that debuted in the show quickly became a calling card for the English designer, continuing to be reimagined in various materials and print in her collections for

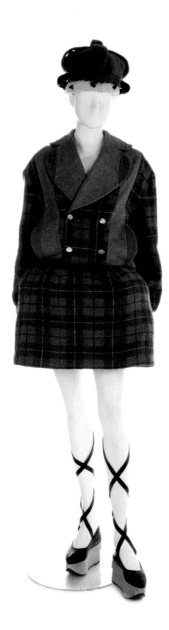

decades to come. Westwood would refer to the garment as the Stature of Liberty, a play on words used to highlight the new-found liberation that these previously restrictive garments now harnessed. It was another step in the direction of bringing pieces previously reserved for under the clothes into the light of day as statement fashion pieces. In a 1990 documentary filmed for *The South Bank Show*, Westwood said, "I play around with the idea of sexuality because I don't like orthodoxy in any shape or form."

Vivienne notes that she spent time throughout the 70s crafting clothing for Teddy Boys by deconstructing suiting from the 50s – a practice that proved useful for designing some of her tailored pieces in the Harris Tweed collection. She once explained, "I am a great believer in copying – there has never been an age in which people have so little respect for the past." The collection would inspire other labels to look at the tweed in a new light and experiment with the material in a new way.

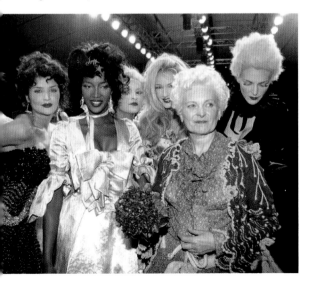

OPPOSITE LEFT
The Harris Tweed collection featured statement styles like mini crini skirts made from the Scottish material and the heart-shaped lapel seen here.

OPPOSITE RIGHT
Westwood's love for corsets was first demonstrated in the Harris Tweed collection with a bustier style similar to the velvet style pictured here.

BELOW Notable favourites of Westwood, Helena Christensen and Naomi Campbell are captured with the Dame following a runway show in Paris.

OPPOSITE A young
Kate Moss walks the
Westwood runway in
a tartan gown with
orb emblem as a part
of the Anglomania
collection at Paris
Fashion Week in
1993.

MODEL FRIENDSHIPS

Westwood's career was reaching new heights at the same time as another fashion phenomenon – the supermodel. Though fashion models have experienced significant popularity since the 1930s, the 90s was truly a model-crazed decade.

Whether a strategic move or not, Westwood's relationship with some of the world's top supermodels played a key role in her success as a household name. Some of the most iconic moments associated with the Westwood name in the 90s would involve some of these famous faces. Naomi Campbell's tumble on the runway. Kate Moss's topless Magnum moment. Carla Bruni and Helena Christensen were also regulars on Westwood's runways, along with the celebrities Patsy Kensit and Sadie Frost.

But there was one model who would do more than just captivate crowds on the runway. Sara Stockbridge was Westwood's muse for much of the mid to late 80s, and was the face of the label from 1985 to 1991. Interviewed by *Dazed* in 2018, Stockbridge recalled, well, not recalling how the two first met – something she admits is probably related to smoking a bit too much marijuana in her younger years. But what is clear is that the pair would go on to create images that inspired fashion lovers across the globe. From gracing the cover of *i-D*'s August 1987 cover with the caption "Vivienne Westwood Crowns Her Muse" to corset ensembles with mini crini styles and Westwood's trademark rocking-horse shoes, Stockbridge became heavily associated with the Westwood *name*.

Susie Cave, model and designer, remembered the impact of Stockbridge in the 80s. "I have a perfect vision of Sara Stockbridge in a tiny black velvet miniskirt and corset and white stockings and frilly lace knickers, with her blonde hair in golden curls, walking down the King's Road, cars colliding

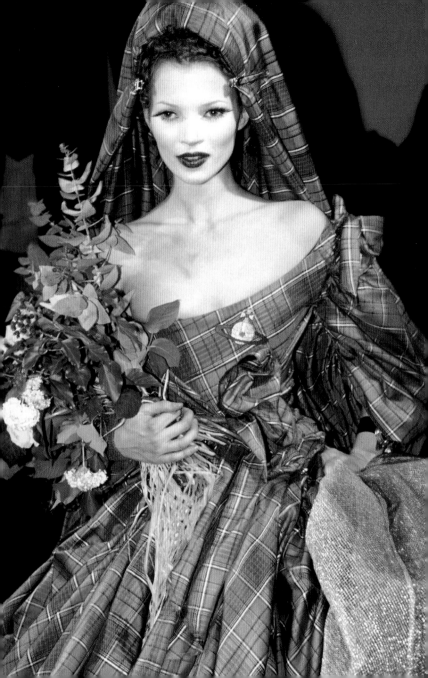

ABOVE Sara
Stockbridge
smiles onstage
with Westwood in
December 1990
as the designer is
awarded Designer of
the Year at the British
Fashion Awards.

as she waved at them, people stopping in their tracks and just gawping, the extreme sexiness of the cut of the clothes."

Journalist Jim Shelley recalls a conversation with Westwood about her brief music project Choice, fronted by Stockbridge: "You see, the idea of Choice is very good for me . . . because it's a platform for all these ideas and, of course, the chance to control a visual image with a singer like Sara is very good for me. She's the sacrificial victim. I'm going to pile all the culture I know onto her, just as you would do if you were going to kill somebody; you put everything that the tribe knew on the victim, all the motifs and totems. And then you torch it."

And more modern queens of the runway have also shown a dedication to Westwood, notably It girl Bella Hadid, who has become a loyal fan of Westwood's designs – on and off the clock. Her admiration for Westwood's designs is noted as one of the key catalysts in sparking appreciation from the younger generation of fashion lovers.

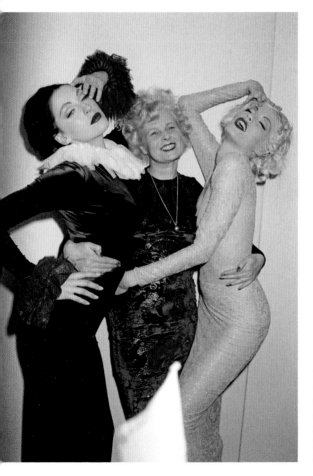

LEFT Models Susie Cave and Sara Stockbridge pose with Westwood backstage at London Fashion Week in 1992.

OPPOSITE
Westwood twirls for
the cameras outside
Buckingham Palace
after being awarded
the OBE in 1992.

THE QUEEN OF PUNK BECOMES A DAME

In 1992, Westwood was recognized for her contribution to British fashion with an OBE (Order of the British Empire). The honour is reserved for a select few who have proven to make significant contribution to their respective fields – in this case, for her contributions to the world of fashion. Westwood's influence on British fashion was honoured in a ceremony at Buckingham Palace on a chilly December day.

But despite the cold, Westwood would opt for a commando approach, showing off her knickerless lower half to photographers as she did a twirl outside the palace. Though she claims this wasn't an intentional act, it solidified her punk spirit and many perceived it as a cheeky grin to the establishment and her complex relationship with it.

"I wished to show off my outfit by twirling the skirt. It did not occur to me that, as the photographers were practically on their knees, the result would be more glamorous than I expected," Westwood later told the press.

In 2006, Westwood received one of the highest honours available to a UK citizen, becoming a Dame Commander (DBE).

ANGLOMANIA A/W 1993

Westwood's A/W 93 Anglomania collection was a prime example of how her love/hate relationship with British culture and history could come together to harmonize in a line-up of head-turning garments. British motifs and symbolism came to life in the form of the Union Jack flag, tons of tartan and, of course, plenty of traditional British tailoring. In contrast to the attention to craftsmanship, Westwood's punk roots made an appearance through deliberately unfinished hems and loose thread across some of the key pieces.

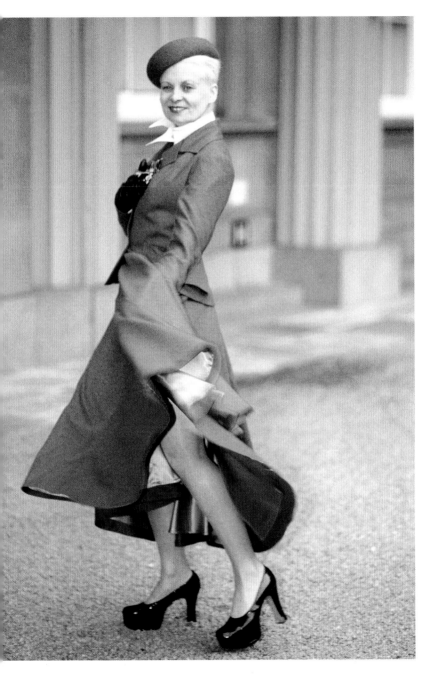

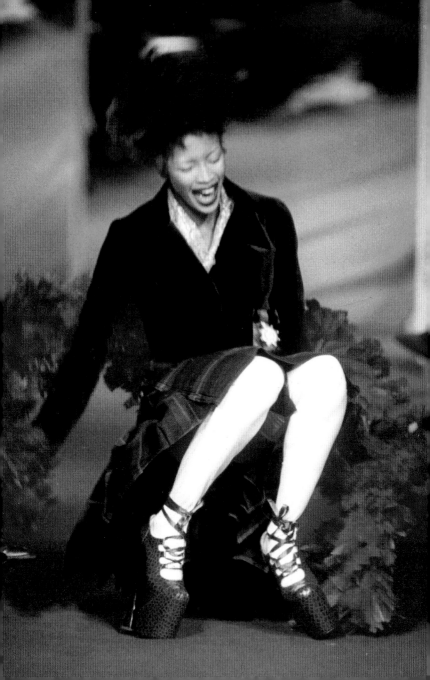

Alongside the designs, the Anglomania collection also made headlines following a painful accident for supermodel Naomi Campbell. Presenting the collection at Paris Fashion Week, Campbell lost her balance while wearing platform shoes with heels a staggering 30.5cm/12 inches high. She took a tumble and the fall became a memorable moment in fashion history. Campbell giggled during the incident before quickly regaining her composure – a true testament to her professionalism. The blue mock-crocodile shoes now sit in the V&A archive – a tribute to the cultural significance of the design.

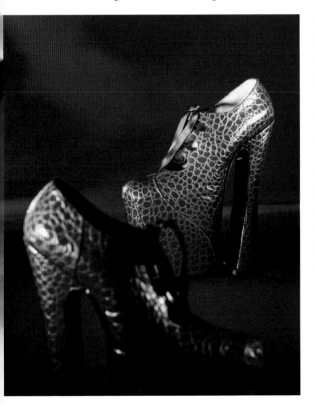

LEFT The iconic crocodile shoes have made an appearance at various fashion exhibitions across the globe, including Vivienne Westwood Shoes: An Exhibition 1973–2010 at Selfridges in 2010.

OPPOSITE Naomi Campbell takes a tumble in a pair of Westwood's Super Elevated Ghilllies, made from mock croc leather, during the 1993 show.

CAFÉ SOCIETY S/S 1994

The Spring/Summer 1994 Café Society collection has a
place in many fans of Westwood's work in the early 90s. The
themes of decadence and glamour that could be found in café
culture across the 20s and 30s came to life on some of the
era's hottest supermodels, and the audience was captivated.

A playful energy was communicated through pastel
colourways, stark white face powder, Elizabethan-inspired
gowns and contrasting fits. Feather features and fringe trim
helped set the styles apart from the crowd, draped across
an impressive line-up of Westwood's favourite models of
the time, including Christy Turlington, Naomi Campbell,
Helena Christensen and Kate Moss. It was Moss who caused
much of the buzz around the collection; she walked the
runway topless, wearing only a micromini skirt and enjoying
a Magnum ice cream.

Rachel Tashjian, Fashion News Director of *Harper's
Bazaar*, later remarked: "The audience applauded. It's hard
to imagine any female designer doing this today without
controversy (or even wanting to!). But her dedication to
making daring statements however they were received is what
made her an exceptional fashion talent."

THE WESTWOOD NAME EXPANDS

As the 90s were winding down, the Westwood brand
began to expand. In 1998, the Anglomania diffusion line
launched. A reaction to the success of her 1993 collection,
the line catered to a younger audience with a more relaxed
approach to fashion, a contrast to her mainline consumers
who took a more daring and high-end approach to their
personal wardrobes.

The expansion of the Westwood brand continued in
1999 with the Red Label, described as a prêt-à-porter line

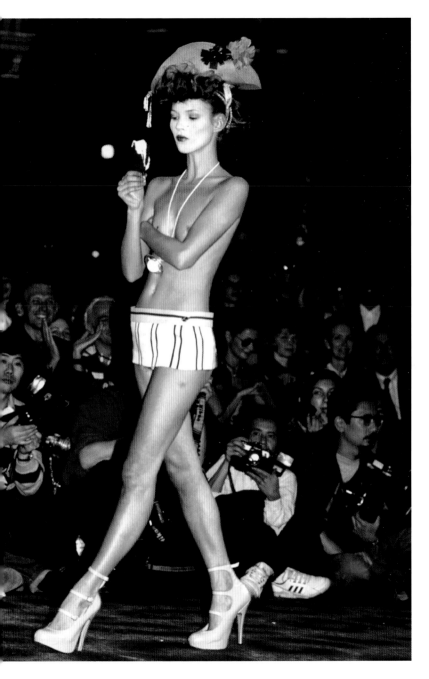

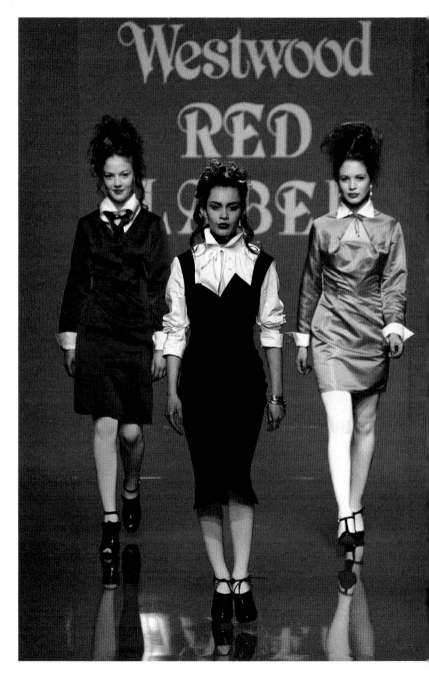

promoting Westwood's affinity for traditional tailoring and French couture. Though, like all good things, the label would evolve over time. By 2015, the label would be used to promote many of Westwood's altruistic messages, seen starkly in their AW15 collection. Models wore clutch bags like arm bands which read "Get A Life" as Westwood pursued her manifesto, urging us to "Vote Green".

In 2016, Westwood announced the end of the Vivienne Westwood Red Label, though the garments released under the name remain fan favourites on second-hand sites and with dedicated collectors across the globe.

OPPOSITE Ahead of its retail launch in 1999, Westwood's A/W 1997 Red Label collection show opened London Fashion Week with models flaunting the ready-to-wear designs for onlookers at the Dorchester Hotel.

BELOW Vivienne Westwood attends the opening of the "Court Couture '92" exhibition at Kensington Palace in July 1992 in London, England.

OVERLEAF Models of the Vivienne Westwood Anglomania A/W 09 collection during the Audi Fashion Festival in Singapore on May 10, 2009.

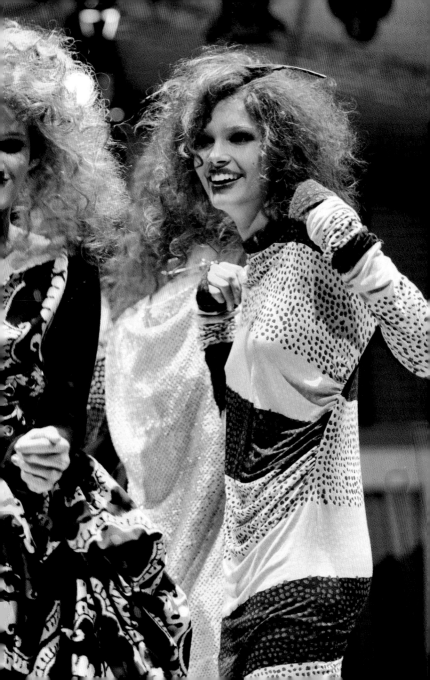

Global Status

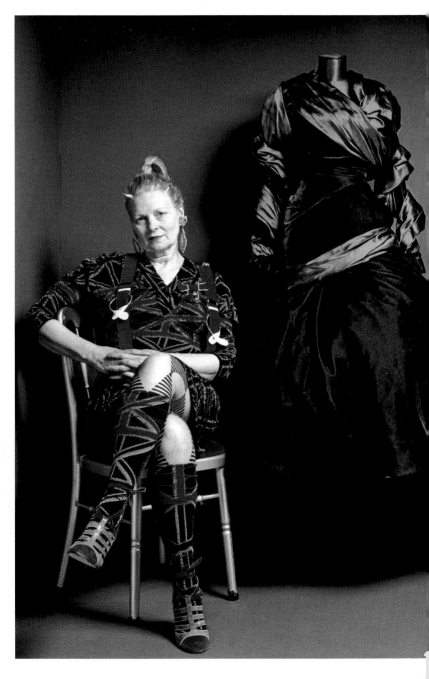

The Dame Becomes a Household Name

"The only reason I am in fashion is to destroy the word 'conformity'. . . Nothing is interesting to me unless it's got that element."
Vivienne Westwood

By the early 2000s, Vivienne Westwood had found herself a mainstay of British fashion. Her ever-evolving relationship with rebellion and traditional British identity made her collections one of the most anticipated by fashion editors and fans alike, season after season. This era was notable for elevating her name, not only as a provocateur but as a talented couturier, sought after by celebrities like Dita Von Teese, who commissioned Westwood to create a wedding dress for her in 2005. Westwood was proving to the world that she could truly do it all – and was beginning to put more political messaging into her world as she did it.

OPPOSITE Westwood sits beside one of her designs as part of a retrospective dedicated to her work at London's Victoria and Albert Museum in 2004.

THE NEW HEIGHTS OF THE 00S

The grip that minimalism had on the 90s was waning, prompting a new thirst for styles with more substance, character and clashing of prints, colours and cuts. And this is very much where Westwood's designs excelled. The appeal was felt by the general public and stars alike. As fashion critic Rachel Tashjian put it: "Whereas most designers who came to prominence in the 1970s or 80s had faded by the mid-2000s, Westwood remained a staple. Who can forget Gwen Stefani fantasizing in her 2004 hit 'Rich Girl': Clean out Vivienne Westwood, in my Galliano gown . . .? Stars like Jennifer Aniston, Kim Kardashian, and Dita Von Teese have worn her gowns with their artfully-draped busts."

RIGHT Gwen Stefani, the No Doubt frontwoman, demonstrated her love for Westwood's designs with many of her wardrobe choices throughout the 00s, including this dress worn to a film premiere in December 2004.

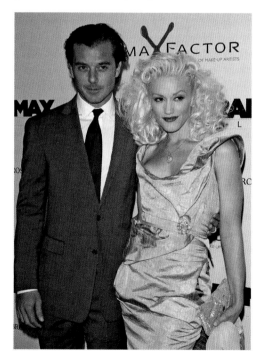

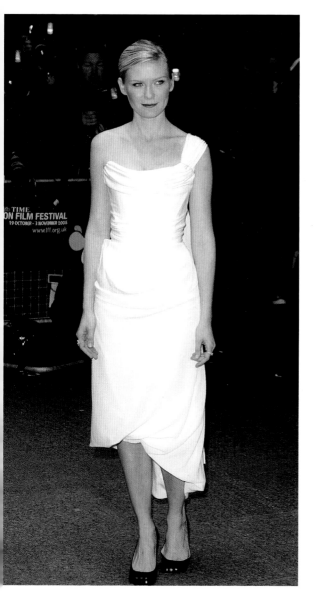

LEFT One of the most beloved actors of the 00s, Kirsten Dunst sports a Westwood gown while attending the premiere of her 2005 film, *Elizabethtown*.

OVERLEAF Westwood graces the runway with her models from the Vivienne Westwood Ready-to-Wear A/W 2005 collection presentation in Paris on March 1, 2005.

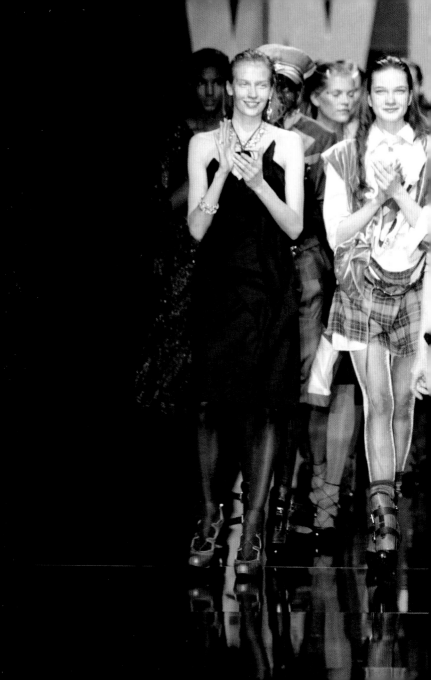

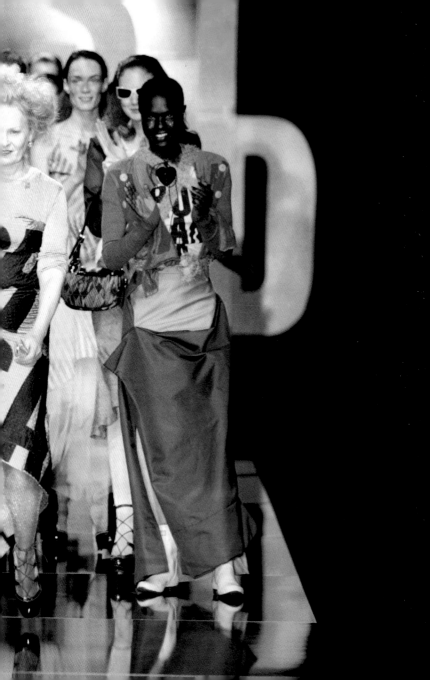

The early 00s saw Westwood continue to explore a range of themes from classic literature ("Reading is the biggest passion of my life, more than fashion," she once said) to big and bold animal prints (in a 2001 Gold Label collection, Wild Beauty) to mythological creatures prominent in the 2002 collection, Nymphs.

Westwood's status was confirmed when one of the world's most iconic fashion museums paid homage to her with a retrospective collection in 2004. Vivienne Westwood: 30 Years in Fashion was hosted by the Victoria and Albert Museum, where she had spent countless hours scouring its archives for

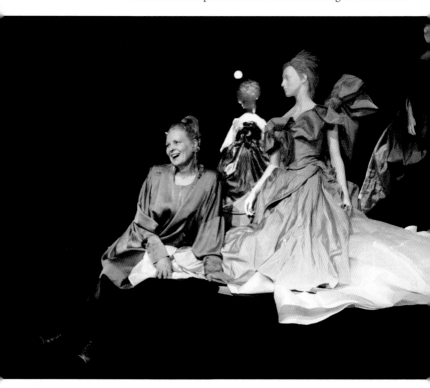

inspiration for her earlier collections, and was the largest exhibition ever devoted to a living British fashion designer. The show notes quoted Westwood: "I've constantly tried to provoke people into thinking afresh and for themselves, to escape their inhibitions and programming."

As the 00s drew to a close, Westwood's dissatisfaction for the world as we know it would translate into more political realms, interwoven with her fashion collections and her acts outside the studio. In 2007, following a meeting with animal welfare charity PETA, she banned all fur products from her collections. From there, she set out to turn her attention to pushing limits and expanding horizons, but also sending clear messages that she believed would push towards the creation of a more just society.

These acts emphasized her dedication to more sustainable practices in the production of her designs, ultimately not only winning her a selection of awards in the area and securing her top spots in many lists of the most environmentally conscious designers but also succeeding in proving, to many, that designer style and eco-friendly practices need not be mutually exclusive enterprises.

THE QUEEN OF PUNK ON THE WORLD'S STAGE

The 2012 Olympic Games marked another key moment for pushing Westwood to the level of a household name, not only in the United Kingdom but across the globe. Standing alongside some of the nation's top models, including Kate Moss and Naomi Campbell, model Lily Donaldson presented a gown by Westwood that would encapsulate her themes and features to onlookers at the Closing Ceremony of the London 2012 events. The Olympic Court dress displayed gold-tone sequins embroidered with metallic thread and its body was formed from organza tulle in an abstract baroque pattern.

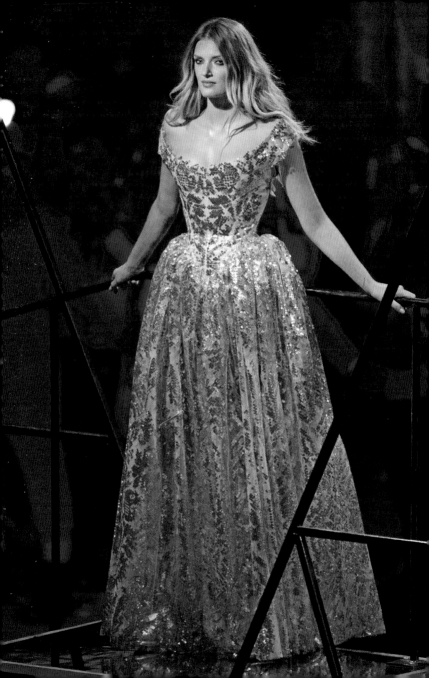

Westwood cited English royalty of the seventeenth century, notably the court of King Charles II, as her inspiration behind the design. The style was first presented at the S/S 12 Gold Label runway show, War and Peace.

But Westwood's impact on British fashion didn't stop there. Pop star Jessie J also paid her respects to her later in the evening, wearing a custom jewel-encrusted nude bodysuit.

"The Closing Ceremony is a celebration of the best of London, the best of British people, and the best of our music and our culture. The most innovative and iconic fashion designers and models in the world are British and so this ceremony would have been impossible without them at its heart," said Kim Gavin, Creative Director of the ceremony.

OPPOSITE Lily Donaldson wears a Westwood gown during the Closing Ceremony of the London 2012 Olympics.

BELOW Singer Jessie J wears a bodysuit designed by Westwood during her performance at the Closing Ceremony of the 2012 Olympics.

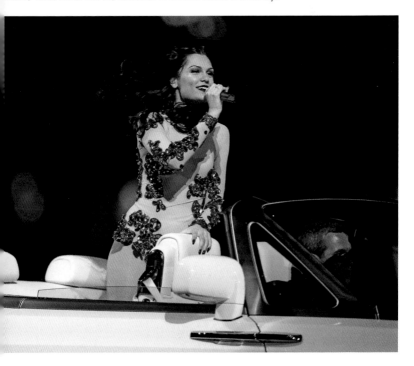

BELOW Pharrell
Williams dons
Westwood's
headline-making
headwear while
attending the 2014
Grammy Awards
ceremony.

PHARRELL DISCOVERS THE BUFFALO HAT

Westwood found herself thrust into the spotlight through
an unlikely source in 2014 when a hip-hop legend's choice of
accessory captured the attention of millions across the world.
Pharrell Williams headed the hit rap group N.E.R.D. in the
90s and 00s before going on to become a renowned music
producer and songwriter. Williams wore the hat alongside a
red leather Adidas track jacket, jeans and Timberland boots
at the Grammy Awards – quite the casual ensemble for such
a high-profile event. But despite the laid-back tone to the
outfit, Williams' fashion of the evening grabbed headlines
("Remember when Pharrell Williams' monumental hat sent the
internet into a frenzy?" reads a 2019 article from CNN Style).

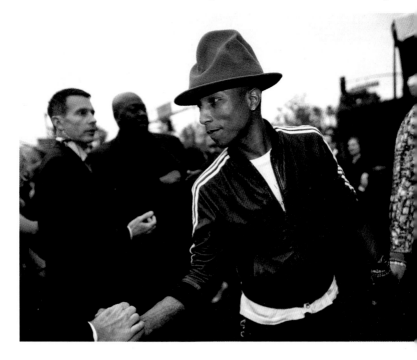

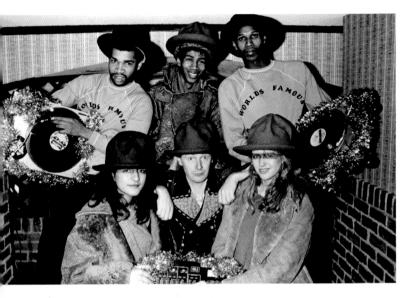

It's reported that Williams first purchased the hat five years earlier at the iconic Worlds End shop, wearing it to various lower-profile events over the years. It'd be safe to assume that McLaren's stint in the hip-hop world (where he wore the famous Buffalo hat from the Buffalo/Nostalgia of Mud collection) is the reason the hat found its way into Williams' world: images of McLaren wearing the design are aplenty, posing with collaborators like the New York City groups the Rock Steady Crew and the World's Famous Supreme Team, members of which can also be seen wearing the headwear piece. The exaggerated height of the Westwood design made it one of the most memorable looks of the event and it would continue to be seen sported by Williams for years to come – becoming more or less synonymous with the Virginia-born star. The public's reaction to the hat was emphasized by a Twitter account dedicated to the hat – earning over 20,000 followers.

ABOVE Malcolm McLaren poses in the Buffalo hat alongside New York hip-hop group the World's Famous Supreme Team, 1983.

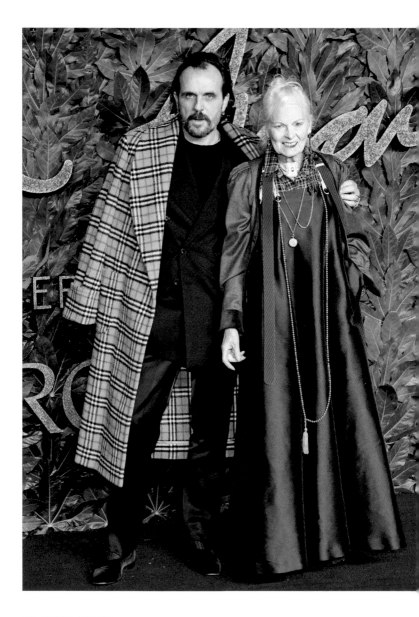

ANDREAS TAKES THE REINS

As Westwood was becoming one of the most renowned British fashion designers of the twentieth century, she also found success in her love life – albeit in a somewhat unexpected setting. While teaching at the Vienna School of Applied Art, she crossed paths with a student named Andreas Kronthaler. Despite an age gap of 25 years, the duo reportedly fell in love and Andreas moved to London to be with Vivienne a year later. Their partnership would span across their romantic relationship into their professional endeavours, with Andreas playing a key role in the Westwood collections from 1991 onwards.

When speaking about Andreas to *i-D* magazine in 2012, Vivienne said, "He's the most incredible, talented person and he's built this business up more than I have. I've got my concepts, but he's cleaned everything up."

By 2010, Andreas' role was clear to all involved with the Westwood brand and he officially became the head, renaming the brand "Andreas Kronthaler for Vivienne Westwood" to reflect this. This shift would allow Vivienne to avert focus to her altruistic pursuits and Andreas to infuse new themes to the collections.

In 2015, the runway shows broke new ground with garments styled on models of all genders – male models sported lamé corset numbers, while the female models were dressed in traditionally more masculine cuts through oversized blazers and baggy trousers that draped to the floor. The concept of playing with gender norms isn't new to the Westwood brand – after all, the New Romantics movement that the designer helped define in the 80s was partially characterized by its subversive take on masculine and feminine binaries. But Kronthaler's take on things was well received, with fashion writer Alexandra Ilyashov remarking, "A coed crop of mods donned tweaked takes on suiting and long, sweeping skirts and

OPPOSITE
Westwood and Kronthaler attend the Fashion Awards in 2018 at the Royal Albert Hall, London.

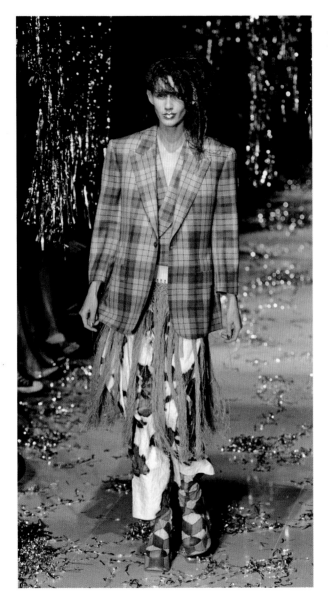

LEFT This model wears a corset gown with frill trim as part of the Andreas Kronthaler for Vivienne Westwood A/W 2015 show in Paris.

OPPOSITE Kronthaler used the A/W 2015 collection to play with gendered clothing, styling traditionally masculine pieces like suiting styles on feminine frames – as Westwood did notably earlier in her career.

OVERLEAF Westwood is joined by a crowd of models as part of her Fash Mob event, which coincided with London Fashion Week in 2015.

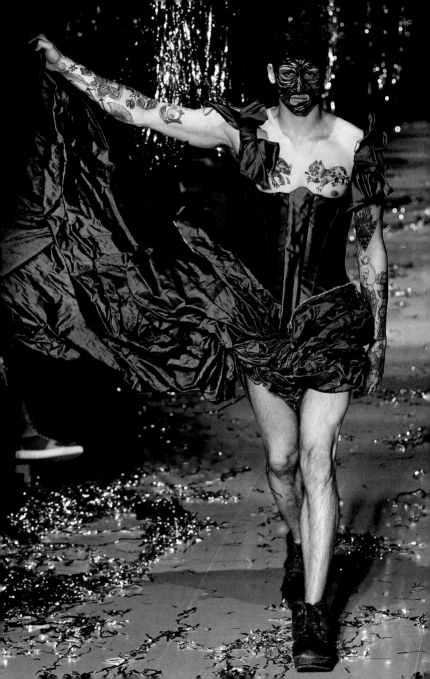

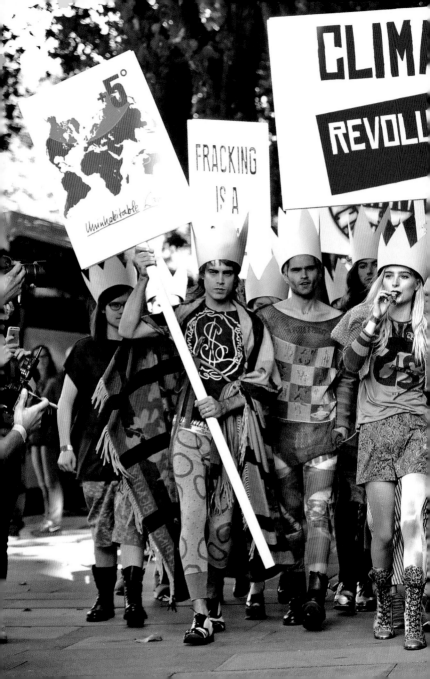

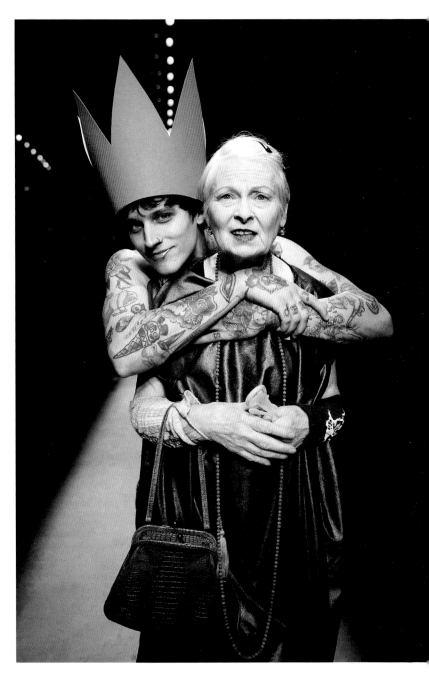

frocks, many topped with hula skirt-esque fringe. Even the blokes wore dresses (and looked pretty good doing so)."

TURNING UP THE VOLUME

In 2015, Westwood took her drive to marry her activism and runway shows to a new level by using her S/S 2016 show at London Fashion Week as the backdrop to an announced demonstration (of sorts), which she cleverly referred to as a "fash mob". The mission behind the stunt was to draw attention to the issue of climate change and encourage people to take action. Westwood gathered a group of models and activists in central London and marched with placards and messages strewn across their clothing – "Climate Revolution", "Fracking is a crime", "Austerity is a crime" and "Politicians are Criminals". On the coinciding collection, she explained: "I've called it Mirror the World. What I mean by that is that you have to understand the world you live in, and you should be a little splinter that mirrors the world. Today you have to understand politics, you have to understand what's going on as well."

Throughout her career, Westwood has used her voice to raise awareness and advocate for various social and environmental causes. Sustainability and human rights were an integral part of who she was and, in turn, what she wanted to accomplish with her brand. In the next chapter, we'll explore the key moments and issues in Westwood's activism work and how she succeeded in establishing herself as a leading voice in the fight for a better future for all.

OPPOSITE A model hugs Westwood at the end of the runway following the London Fashion Week S/S 2016 presentation.

Westwood Fights for a Better World

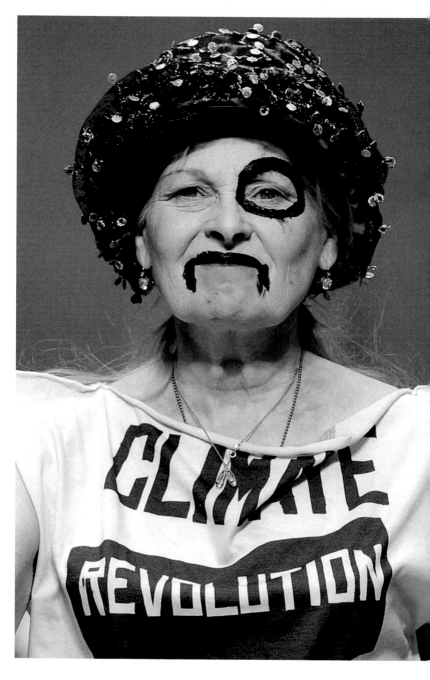

Using her Voice
for Change

"My motto is: Buy Less, Choose Well, Make it Last. You can change your lifestyle and it will cost you less. Essentially we are all trained to be consumers. You have to invest in culture, not in consumption."
Vivienne Westwood

Though never known for her sheepish character, Westwood became increasingly outspoken and committed to using her brand and profile to raise awareness for the causes close to her heart through the 00s up until her passing in 2022. From banning fur in her collections in 2007 to the launch of The Vivienne Foundation in 2023, Westwood's high-profile messages would assist in shaping her into one of the most altruistic fashion designers of modern times.

"Dear friends. We all love art, and some of you claim to be artists," she began in a message she communicated to onlookers

OPPOSITE Vivienne Westwood makes an appearance on the runway following her show hosted at the British Foreign & Commonwealth Office in September 2012 in London.

in 2008 at the Serpentine's Manifesto Marathon. The 22-page manifesto, entitled Active Resistance to Propaganda, was one of the first in a series of public outcries, encouraging both the public and various corporations to take action to create a more just world – for the earth and all its inhabitants.

A few years later, Westwood's thoughts had developed and she rejected her earlier manifesto. "I wrote it a couple of years ago. A few months ago it hit me. We absolutely must save the rainforests. Have we really got time to be art lovers?" Now she worked alongside Lee Jeans on a project called "100 Days of Active Resistance". This took the form of a digital exhibition, which asked individuals to submit their own artwork, slogan, or photograph in response to the theme.

At the time, Westwood claimed, "It is not enough to follow world politics, see films and read the prizewinning bestsellers ... this is superficial, you need to go deep in order to understand who you are, what the world is and how things could be better. This involves culture which can only be acquired by self-education: human beings should mirror the world." The project was also accompanied by a book of the same name, released in 2008.

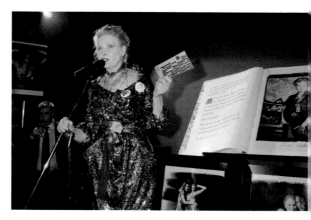

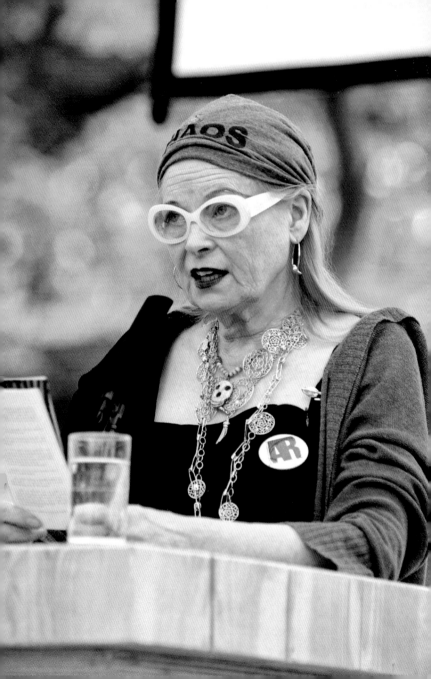

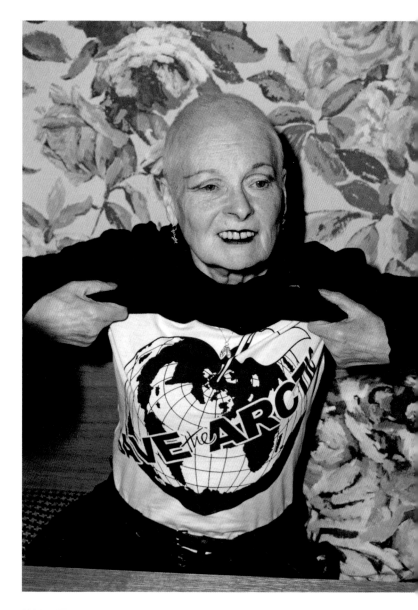

OPPOSITE
Westwood shows off
her Save the Arctic
T-shirt at a 2014
event with PETA,
organized to highlight
the issue of water
being wasted by the
meat industry.

PETA INVOLVEMENT

After banning fur from her designs in 2007 (after which she reportedly donated a range of fur-lined handbags to an animal sanctuary so that orphaned animals could snuggle up to them), Westwood began to experiment with vegan materials in her collections, including the Derby Bag and Jungle Crocodile Bag made using vegan materials, which scored multiple wins for the label in PETA's annual Vegan Fashion Awards of 2013.

The next year, on World Water Day, PETA released a campaign that depicted Westwood going nude in the shower to raise awareness of the excessive water usage required in farming animals for human consumption. Westwood announced, "I am an eco-warrior, but I take long showers with a clean conscience because I'm vegetarian."

Westwood's dedication to promoting cruelty-free practices made an appearance in many of her collections from the mid 00s, including the Vegan Botanical Range for A/W 2020 featuring the Bird of Paradise print and nylon recycled from bottles and clothing scraps.

IT'S TIME FOR A CLIMATE REVOLUTION

In 2012, a few years after her speech at the Serpentine, Westwood announced the launch of her environmental organization, Climate Revolution. The initiative was created in the hope of bringing awareness to issues caused by climate change across the globe and offering a platform for activists to come together and work towards solutions. Climate Revolution's mission was to bring individuals, charities and NGOs together to protect the wellbeing of the planet with a focus on the rainforest and oceans, while working together to achieve a new economy. Westwood believed that by challenging disengaged political leaders and big businesses,

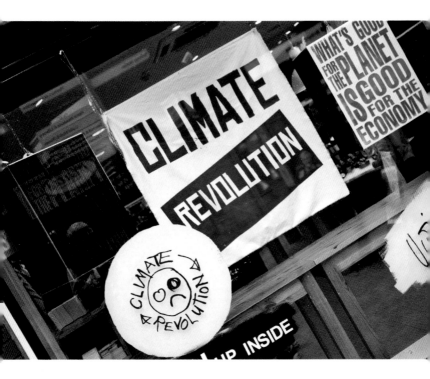

ABOVE Westwood's Climate Revolution initiative used bold branding and action-oriented messaging to catch high-street shoppers with this window display from 2014.

the group could help reduce the reliance on fossil fuels and harmful practices that contribute to the climate emergency.

The project would go on to collaborate with fellow British brand Lush around the 2014 Christmas shopping season, creating a series of limited edition branded scarves to encourage reusable wrapping.

GREEN ENERGY

For her A/W 17 show, Westwood used the runway to highlight another aspect of environmentalism close to her heart. One of the first collections after her announcement to switch to unisex collections as a way to cut down on waste, the A/W 17 line-up

LEFT A model walks the runway for Westwood's A/W 17 show during London Fashion Week Mens.

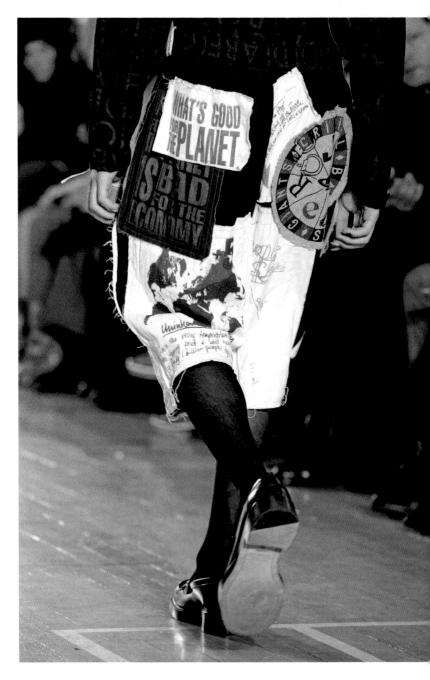

was simply named Ecotricity, an ode to the green energy company that Westwood teamed up with on the collection. Among the sea of knitwear and patchwork styles of the season several messages featured, like "What's good for the planet... is bad for the economy", which was printed across a pair of trousers, and "Intellectuals Unite" on the models' wristbands, referencing the book club initiative calling for people in the academic sphere to come together to share ideas on how to push for a better world and conservation of the planets and its inhabitants.

"The only way to save our lives and future is to switch to green energy," Westwood claimed. "We must all demand a fast transition to clean energy. We require a Green Economy for human life to flourish and remain sustainable. Switching to Ecotricity speeds up this transition and also gives money to Fuel Poverty Action." She added, "Importantly, the Big 6 energy companies – most of whom are anti-environment and anti-life – will be delivered a fatal blow, with more and more people switching to green energy suppliers."

ANTI-FRACKING

"We've got a war to stop climate change," Westwood shared with *Dazed*, "and the first battle is to stop the government from forcing fracking on people." This was the statement she made as she led the Fracked Future demonstration through the streets of London in March 2014. The next year Westwood made one of her biggest statements yet. Sourcing a white army tank, she approached the Chadlington home of then Prime Minister David Cameron. Her surprise visit was prompted by the announcement that 27 locations in Yorkshire had been approved as fracking sites, a dangerous process that produces notable pollutants and earth tremors.

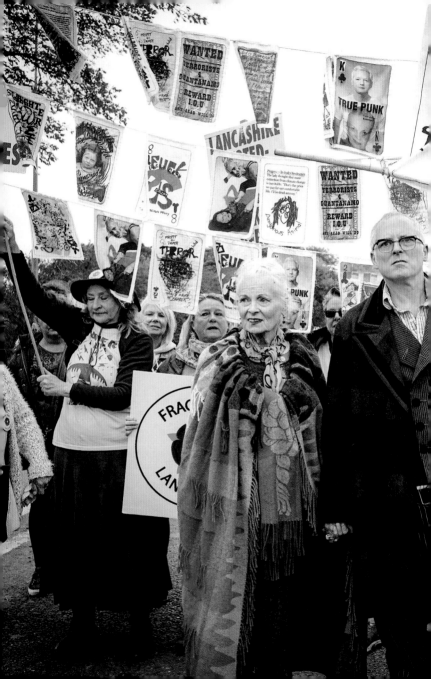

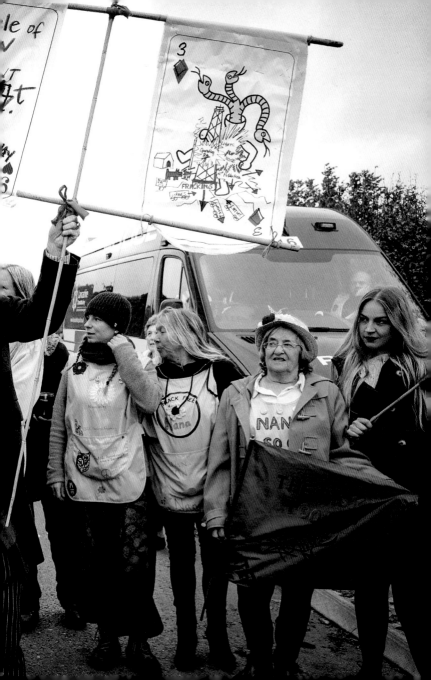

Westwood articulated her message with a statement: "Cameron accuses foreign leaders such as President Gaddafi and President Assad of supposedly using chemicals on their own people as a justification for regime change . . . But he is doing precisely that here in Britain by forcing toxic, life-threatening fracking chemicals on his own people against the advice of his own chief scientist."

In 2018, Westwood made it clear that demonstrating against fracking wasn't a thing of the past. Travelling to Yorkshire with her son and fellow activist Joe Corré in tow, she appeared on the public highway in front of energy firm Cuadrilla's fracking well gates on Preston New Road to stand with locals for the #RightToProtest.

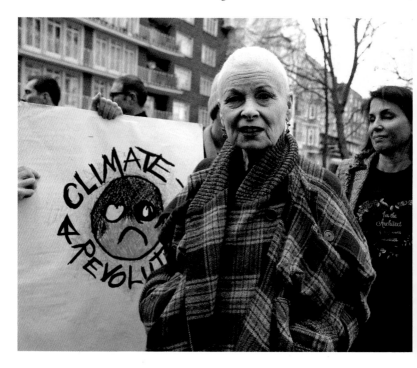

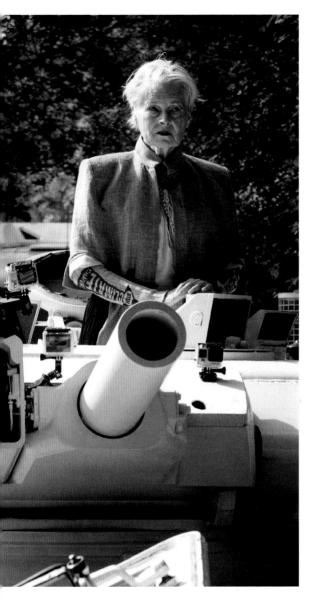

LEFT In 2015, Westwood made a noteworthy visit to David Cameron's home in Dean, Oxfordshire, standing upon a white army tank to confront the then Prime Minister on his fracking policies.

OVERLEAF In July 2020, Westwood presented herself in a cage suspended outside the Old Bailey, shouting her support for WikiLeaks founder Julian Assange.

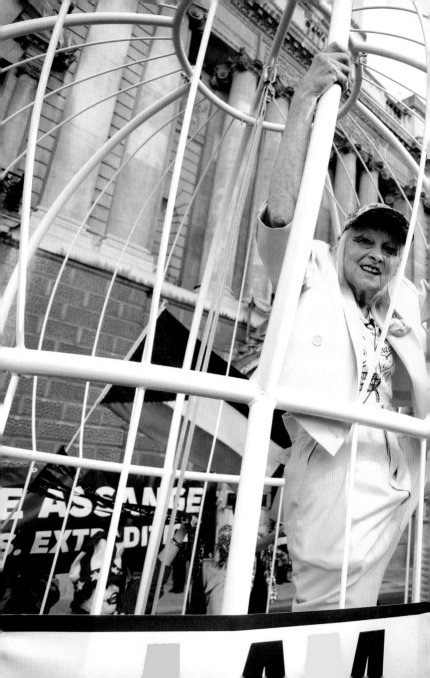

OPPOSITE
Westwood walks
the runway in a
T-shirt that reads "I
am Julian Assange"
during Milan Men's
Fashion Week S/S
2017 in June 2016.

SUPPORT FOR JULIAN ASSANGE

In 2012, Westwood openly supported WikiLeaks founder Julian Assange with a T-shirt design featuring her own face and the message "I'm Julian Assange" – a nod to the supporters who protested his extradition outside the Ecuadorian Embassy in London, sporting placards announcing: "I'm Julian Assange". His fight for diplomatic asylum was supported by the proceeds of the T-shirts, which sold for £40 on viviennewestwood.com. "T-shirts for Julian: you can show your support of a real hero by going to viviennewestwood.com. Donations to WikiLeaks have been blocked but 100 percent of T-shirt profits can help fund their work," Westwood claimed on her blog.

Assange spoke to Hypebeast in 2017 about the unlikely friendship between himself and Westwood: "I've met a lot of people, we have different types of supporters but yeah, it is completely unique in that she has been so successful in what she does. She also owns what she does, she doesn't work for someone else: she really can do anything with her life. She's not supporting me for the likes or the increased exposure, she's choosing to do it because she has a vision for what she believes is right."

The Australian hacker would go on to comment on Westwood's merchandise created to support him, saying, "She did a runway and she rented the space out inside the Foreign & Commonwealth office . . . my dispute with the British government is really with the Foreign & Commonwealth office because they are responsible for public affairs, embassies, MI6, and GCHQ – and so she had her models wearing Julian Assange T-shirts . . . inside the Foreign & Commonwealth Office – that's a kind of epic trolling on the state . . ."

And who could forget Westwood's 2020 stunt that saw her dressed in bright yellow in a cage outside the Old Bailey? Alongside a giant sign reading: "I am Julian Assange",

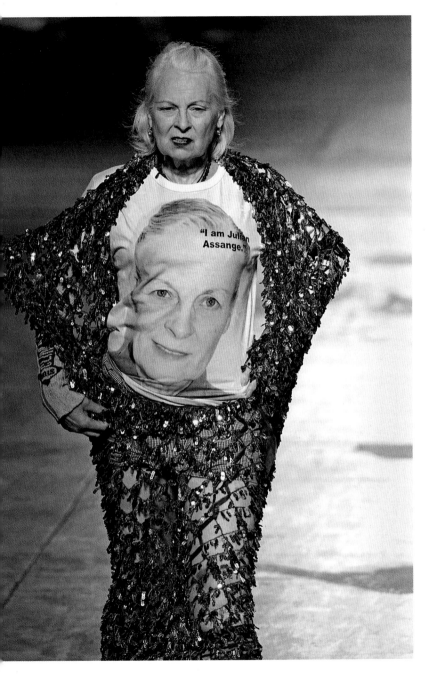

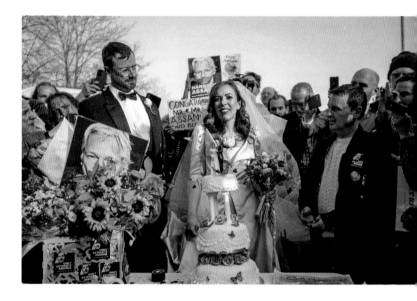

ABOVE Supporters surround Stella Assange (née Sara Gonzalez Devant) wearing her wedding dress designed by Westwood outside Belmarsh Prison in March 2022.

OPPOSITE Westwood calls for action to help fight climate change on stage during BoF VOICES 2021 on December 1, 2021 in Oxfordshire, England.

Westwood shouted, "I am the canary in the coal mine. If I die down in the coal mine from poisonous gas, then that's the signal. . . I am a canary. I am half poisoned already from government corruption and gaming of the system and legal system by governments."

Westwood's support for Assange would last until her death in late 2022. A final act of solidarity had come earlier that same year when she designed a custom gown for Stella Moris, who would marry Assange at Belmarsh Prison. The gown was embroidered with messages from friends and family of the couple and a personal note from Westwood herself stitched into the dress's skirt panel – and, of course, a corset-style bustier reminiscent of one of Westwood's iconic corset designs.

Assange famously requested to attend her funeral in 2023, but the request was ultimately denied. Westwood's family expressed their disappointment, though not their surprise:

"Julian has not yet been convicted of any crime, yet he is treated as if he is a terrorist, the only thing he is guilty of is publishing the truth."

HER LETTER TO THE EARTH

In 2021, Westwood was in her eighth decade, but her passion for activism was only growing stronger, demonstrated by her actions at Shakespeare's Globe on a chilly October day. Here, she read her contribution to the Letters to the Earth project, launched by three writers in 2019. Westwood's contribution discussed various themes, including promoting a land-based economy and opening up land corridors for wildlife. Yoko Ono and Mark Rylance were among other celebrities who took part in the global project, writing letters about their environmental

OVERLEAF On September 14, 2021 in London, Westwood joined anti-war activists groups including the Campaign for Nuclear Disarmament in protesting against the Defence and Security Equipment International (DSEI).

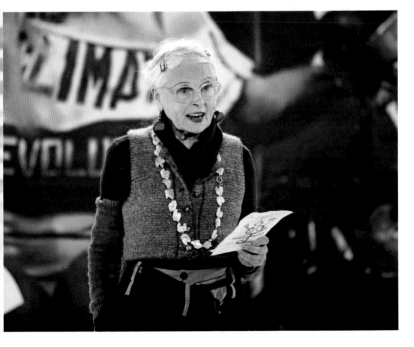

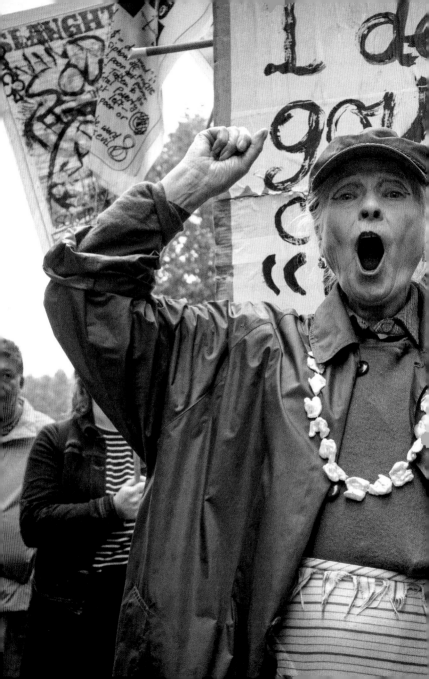

concerns to raise awareness and encourage action.

Westwood shared an excerpt of her letter on her website that highlighted the relationship between economy and sustainability and the current financial system being rooted in trade war. Instead, Westwood argues, economy should be based on the value of land – a resource that she staunchly states, belongs to no one. She would go on to build on this in an interview with Reuters in October 2021 when she shared, "Rewilding is not to do with stop farming and let everything go, it's to do with start farming in collaboration with nature. Let nature bring the soil back to health."

THE VIVIENNE FOUNDATION

First established in 2019, a few years before her passing, The Vivienne Foundation acted as a hub where all of Westwood's altruistic efforts could come together for maximum impact. The mission statement reads, "We are built upon four inextricably linked pillars of change – halt climate change, stop war, defend human rights and protest capitalism. We seek to raise awareness and fundraise for organisations aligned with Vivienne's mission to save the world."

The not-for-profit organization officially launched in early 2023, shortly after Westwood's passing, gaining attention from fans of the late Dame from around the world. The work of the organization is reported to be focused on Vivienne's belief that government cooperation is necessary in order to make the most impact. The Vivienne Foundation aims to work with NGOs, scientists and experts to impose changes to the legal system that will help protect the planet, believing this as a vital factor for tangible change.

Cora Corré, model and granddaughter of Westwood, promoted the work of the organization around the time of Westwood's passing, telling *ES Magazine* in one interview,

"I have always been in admiration of her . . . of her intellect and her striving for justice. We had planned to do a series of intergenerational talks. . . I find that a lot of people — although intelligent — don't go out of their way to fight against injustices. . . For my generation and generations to come, we are the future and it's on us to fight in this battle for change."

As a part of its Stop War campaign alone, The Vivienne Foundation worked to donate funds to the Refugee Council, War Child and the Campaign Against Arms Trade (CAAT).

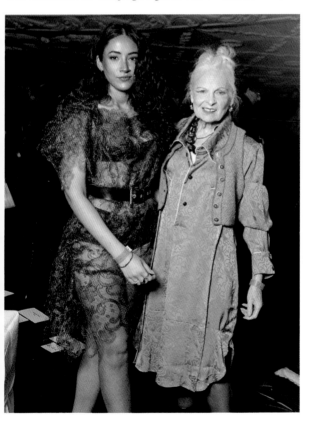

LEFT Westwood and granddaughter Cora Corré attend Paris Fashion Week on March 5, 2022.

Her Legacy

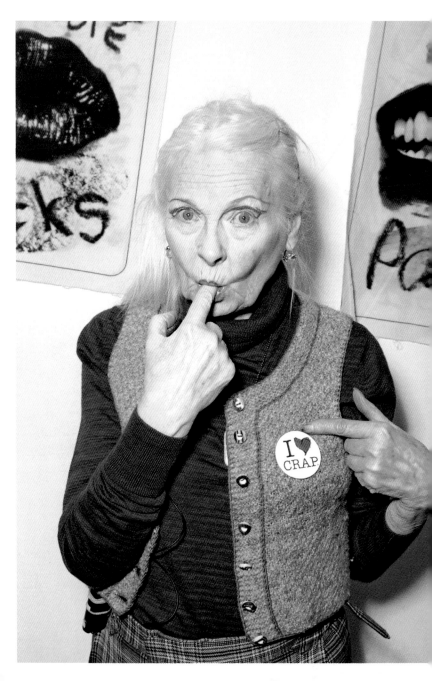

Inspiring a New Generation

"She was a reckoner who pushed the needle of British Fashion and continued in that fearless original spirit her entire career. She tore apart notions of femininity, sex, and was one of the first to demand that fashion do better in regards to the climate and without a doubt was one of the most effortlessly original people I've ever met. Fashion, art, culture will mourn this loss of a gargantuan woman who shaped how we wear and what we wore."

Karen Elson

VIVIENNE INFLUENCES A NEW GENERATION

Westwood's influence on fashion and pop culture across the globe never did experience a lull. But in the few years before her passing, her influence could be felt in a whole new way – and in even the most unlikely corners of modern culture.

The Japanese affinity for Westwood's designs and ethos have appeared throughout the decades, beginning with winning a

OPPOSITE Vivienne Westwood curates an exhibition for London Fashion Week, February 2020, at the Serpentine Gallery.

spot at Hanae Mori's 'Best of Five' global fashion awards in 1984 through to Gwen Stefani's infusion of the designer's looks into her Harajuku Girls era in the mid 00s. Westwood's designs had long been some of Japan's favourite UK exports when it came to fashion – and the feeling was mutual. And one unlikely piece of evidence for this is found in the form of the anime created by Ai Yazawa.

Silvia Trevisson unpacks this in a 2022 article for *NSS Magazine*: "Ai Yazawa remains one of the most famous names in the world of anime and manga. . . . Her characters are young adults grappling with complex issues. But the real reason for her success, which still fascinates the new generations, is her long liaison with the fashion world, and especially with Vivienne Westwood."

Ai Yazawa's characters are often depicted in Westwood's key styles, like the Orb necklace and ripped tops reminiscent of the 70s styles sold on the racks of Seditionaries. Trevisson credits the resurgence of Anime like Nana for adding to the new

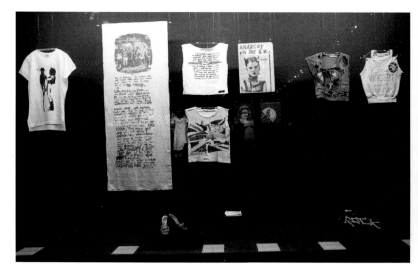

generation of Westwood fans: "Many young people come into contact with punk fashion through the fascinating production of Ai Yazawa, immortalizing once again the various facets of a self-expressive style that never stops evolving."

The reality is that the younger generation's obsession with Westwood and, in particular, some of her staple pieces like the Orb necklace, can be linked to a few varied sources. And, we can all agree, TikTok is undoubtedly one of them. To unofficially be rebranded as "the TikTok necklace" is no easy feat. The platform creates and destroys trends at an alarming rate – but the Vivienne Westwood Orb necklace has truly

RIGHT Model Bella Hadid sports the iconic Westwood pearl necklace that took TikTok by storm.

taken TikTok by storm. *Grazia* journalist Natalie Hammond speculated on the reasons in a 2021 article, stating, "Then there's the element of nostalgia, which always goes down a treat on TikTok. (Westwood first sent a pearl necklace down the catwalk in 1987, introducing the three-row pearl choker three years later in 1990.) No wonder today's influencer/It girls, who have already mined the '90s for its leather coats, tinted

sunglasses, shoulder bags and boot-cut jeans, have come knocking."

The *New York Times* also caught on to the hype, unpicking it in an article published in October 2021: "The necklace, which imbues prim pearls with a bit of punk, is one of many vintage Westwood items that have found young fans online, thanks to a combination of factors: famous brand-boosters (Rihanna, Zendaya, Dua Lipa, Bella Hadid and Lisa Manobal of the K-pop group Blackpink, to name a few); nostalgia for clothing made from the 90s and mid-2000s; and the resurgence of a stylish anime television series from that era called 'Nana.'"

VIVIENNE ON THE BIG SCREEN

Westwood's global status as a fashion icon was confirmed in one of the highest-grossing films of the decade, which brought in a staggering US $415 million. The *Sex and the City* movie showcased Charlotte, Miranda, Samantha and, of course, Carrie as she prepared to marry her elusive Mr. Big. The TV series played a key role in bringing high-end designers to the mainstream and inspired women the world over to dream about owning their very own pair of Manolo Blahnik shoes or a handbag from one of the boutiques frequented by Carrie Bradshaw and Co.

So, when it came to choosing her most important outfit to date, Carrie had to get the look just right. Her wedding dress would have to be big and bold, yet elegant with a touch of avant-garde charm. Sarah Jessica Parker's character knew exactly what she needed: "A dress so special that it could bring a wedding tear from even the most unbelieving." Vivienne Westwood had just the dress. Enter an ivory silk gown with corset bodice and Radzimir taffeta. The dress instantly drew admirers and conjured a thirst for many to get their hands on the gown for themselves, a spokesperson told *Glamour* in 2009.

OPPOSITE *Sex and the City*'s Carrie Bradshaw, played by Sarah Jessica Parker, donned Vivienne Westwood for her much-anticipated wedding to Mr. Big in the 2008 film.

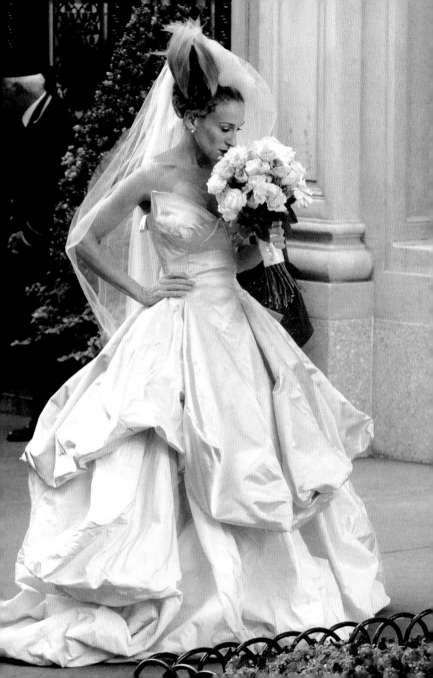

BELOW Thomas Brodie-Sangster played Malcolm McLaren while Talulah Riley depicted Vivienne Westwood in the 2022 production *Pistol*, directed by Danny Boyle.

"Our wedding dress always captures the essence of the collection to its most extreme and is the highlight piece. In the film, Carrie was sent many choices, however, the dress designed by Vivienne Westwood obviously stood out amongst others and became her choice for her wedding. *Sex and the City* has definitely helped raise the popularity and visibility of this dress."

The dress would make another appearance in the spinoff series *And Just Like That…* in 2022.

A TV THROWBACK

In 2022, Scottish director Danny Boyle released a six-part series depicting the happenings surrounding the Sex Pistols through the 1970s. The awkwardly placed Disney+ series stars Thomas Brodie-Sangster as a young Malcolm McLaren and Talulah

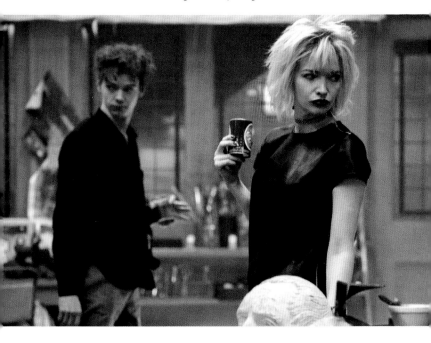

Riley as Vivienne. Said Riley: "She is an absolute icon. It's one of those things when you get through it and you think 'Really am I allowed to have a go at this? This is so exciting.' Also with the whole punk ethos at the time our costumes were incredible."

Unsurprisingly, some of the other key subjects were none too pleased with the work, John Lydon telling the press, "Disney have stolen the past and created a fairytale, which bears little resemblance to the truth." Director Danny Boyle is quick to own up to the series' semi-fictional nature, telling *Vanity Fair*, "It's not a documentary because . . . there isn't one version of the truth here," he says. "You just have to hope that the essence that you get is faithful enough to enough of it to warrant being taken seriously."

But where the plot may divert from the facts from time to time, the wardrobe succeeds in its accuracy, partly due to the involvement of Jordan. In an unfortunate twist, she wouldn't live long enough to see the series air. Maisie Williams, who played her said: "She was desperate to. She did get to come on set and watch us film. And she did get to piece together a lot of the sets and costumes and hair and makeup. So many of the decisions are from Jordan, so I think that's special and poetic in a sad way."

THE PASSING OF A LEGEND

In December 2022, aged 81, Vivienne Westwood passed away in her Clapham home, surrounded by friends and family. Her death shocked and saddened much of the fashion world and fans across the world quickly took to social media to voice their respects to the late fashion designer.

Naomi Campbell shared her admiration for Westwood: "You were a force of nature, that would always encourage me to push forward and not give up on things I was passionate about doing outside of modeling. Your honesty was to be

ABOVE A tribute to Westwood is displayed in the window of the Vivienne Westwood Man store on London's Conduit Street, Mayfair, shortly after the designer's death in December 2022.

valued whether we liked to hear it or not, you spoke your truth, real and authentic."

That sentiment was shared by many, including Donatella Versace: "Vivienne was an iconic pioneer in Fashion and its greatest Punk. She broke all of the establishment rules to make clothes that spoke of independence, rebellion and power. She gave generations of young people new codes to express themselves."

Stella McCartney highlighted the designer's invaluable contributions to making the fashion world a better place in her ode to Westwood: "Vivienne invented historic fashion design moments that woke us all up and shook the industry to its core. She led the way forward, never apologising for exposing unjust wrongs in the world and asking uncomfortable questions. Vivienne said it like she saw it. She wanted to make fashion better."

And beyond the tributes in written form, flowers towered outside Westwood's Clapham home and the Worlds End shop on the King's Road, two iconic spots associated with Westwood's heart and creative genius. There was even a mural that appeared in Vivienne's birthplace of Glossop shortly following her passing. It was evident that the fashion world had lost a key player and a true icon whose influence spanned across disciplines and countries the world over.

In February 2023, a memorial for the history books took place for Westwood at London's Southwark Cathedral. In attendance were guests from a wide range of backgrounds and disciplines, including Nick and Susie Cave, Kate Moss, Victoria Beckham, Helena Bonham Carter, Tracey Emin, Brian Cox and Stormzy. If that breadth of attendees doesn't prove how far Westwood's influence reached, nothing will.

BELOW Flowers and cards piled up outside Westwood's Clapham home with messages from fans paying their respects.

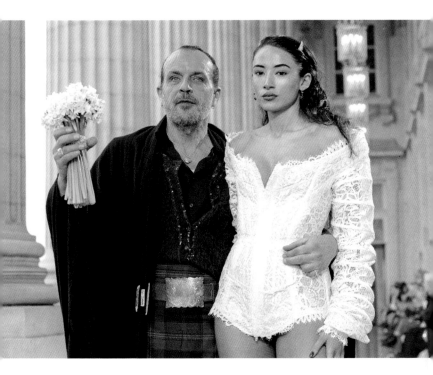

ABOVE Andreas
Kronthaler and
Cora Corré walk the
runway following the
Vivienne Westwood
Womenswear A/W
2023 show at Paris
Fashion Week on
March 4, 2023.

ANDREAS' ODE ON THE RUNWAY

Westwood's husband and long-time collaborator took the
chance to pay homage to his late wife on the runway of the
Andreas Kronthaler for Vivienne Westwood A/W 2023 show,
presented at Paris Fashion Week on March 4, 2023. Place de
la Concorde, the breathtaking venue, was filled with admirers
of Westwood, including Julia Fox, Halsey and designer Jean
Paul Gaultier. The runway was graced by some of Westwood's
nearest and dearest, including Sara Stockbridge and Cora
Corré, Westwood's granddaughter.

Kronthaler would remark that the collection was
undoubtedly a tribute to the iconic fashion designer and

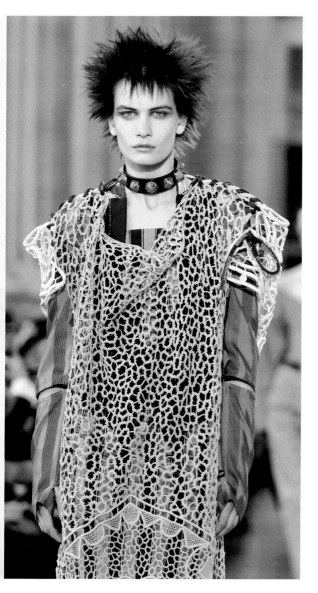

LEFT A model sports spikey hair and a leather choker necklace, reminiscent of some of Westwood's looks of the mid to late 70s on the runway during the Vivienne Westwood Ready to Wear A/W 2023.

her stark dedication to environmentally-friendly fashion, referencing the use of second-hand fabrics and the therapeutic impact of using them: "I collect and hang on to things but this time I just [needed] to get rid of it." He went on to tell *W* magazine: "It is my very personal tribute to her . . . I think it's a very helpful process to go through something like this. I can create a new situation for myself. But at the moment, it's just still a strange period."

The collection itself summarized much of what Westwood was known for: bold tartan, regal-inspired imagery, crinoline cuts, men in bodysuits, billowing gowns – and, of course, those trademark corsets. "You once said to me take everything away, just leave me my platform shoes because one can't do without them . . . Maybe the most important thing you ever taught me was to put women on a pedestal," Kronthaler shared in the moving show notes for the collection.

KEEPING HER SPIRIT ALIVE

Vivienne Westwood's impact across the fashion industry (and culture, in general) is undeniable. Her fashion designs were always one step ahead, pushing boundaries and challenging the status quo. So there's a touch of irony that her innovative designs have now become sought after in the vintage world, with collectors taking a particular interest in the Seditionaries and Anglomania eras, as seen on second-hand platforms like Vestiaire Collective and 1stDibs.

"Some of the most collectable work is from the early 80s, when it had broken through to the style press, which shaped a cult around it," says journalist and Westwood collector Mark C O'Flaherty. "Those sharp-shouldered, deeply weird and wonderful Witches jackets from 1983 can go for more than £15,000. There are rarely gently priced vintage pieces from pre-mid-90s."

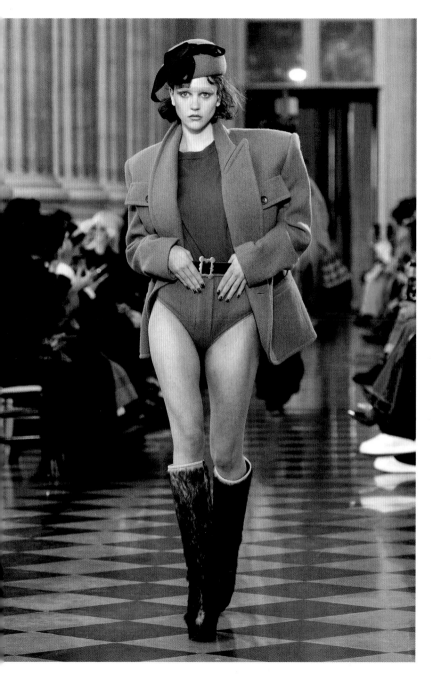

BELOW Portraits of Westwood herself appeared on a number of the 2023 collection's styles, including this muslin top with statement sleeves.

But Westwood's impact on the fashion industry goes far beyond her contributions to dress. She also inspired countless designers and creative minds with her DIY attitude and punk aesthetic.

Dr. Monica Sklar, a fashion history professor at the University of Georgia, recalls, "Westwood was a designer we always looked up to as kids. . . The combination of preferences, punk and historical dress has had a very strong impact on us and has shaped us so much as designers. The DIY attitude inspired us to get into fashion – to just try making stuff without the fear of everything [having to be] perfect."

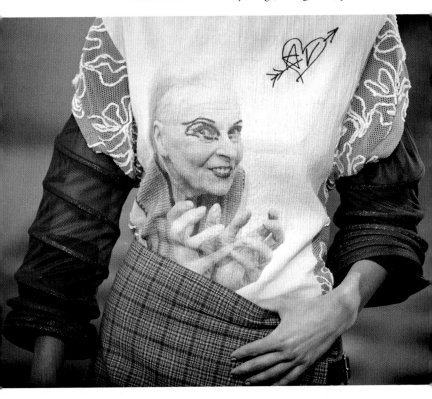

LEFT Japanese fashion blogger Nibu Shiomi wears a Seditionaries T-shirt with the famous cowboys print while attending Paris Fashion Week in 2015.

As an outspoken activist, Westwood's passion for equality and creating a better place for earth and all its inhabitants was reflected in her designs, such as the famous T-shirt featuring two naked cowboys, which paved the way for LGBTQ+ representation in fashion.

"Everyone wearing all these patches or pins or even things jammed into their Crocs. People like Westwood made that an option by printing two men having sex on a shirt. So when we're advocating for trans rights or LGBTQ rights now, she was authentically on the right side of history long ago. And that kind of activism is what people are really feeling right now," adds Sklar.

"There is no one more influential than Vivienne on late twentieth- and twenty-first-century fashion," says milliner Stephen Jones. "Without Vivienne there is no Rei [Kawakubo], no John [Galliano], no Lee McQueen nor a hundred other designers nor a million punks around the world for whom she was, and is, the Queen of Fashion."

Westwood's legacy lives on through her brand and the designers she inspired. "Westwood has created a brand that is unique, radical and rebellious and through Kronthaler's creative vision there is hope that the spirit of Westwood will live on," writes fashion professor Naomi Braithwaite.

Model Erin O'Connor put it perfectly when she said, "Dame Vivienne Westwood's spirit, tenacity and legacy must live on." She went on to refer to Westwood as "an incomparable human being who possessed such power and purpose in her lifetime which she shared the world over with relentless fortitude. We owe it to her memory and future generations to continue her vital work."

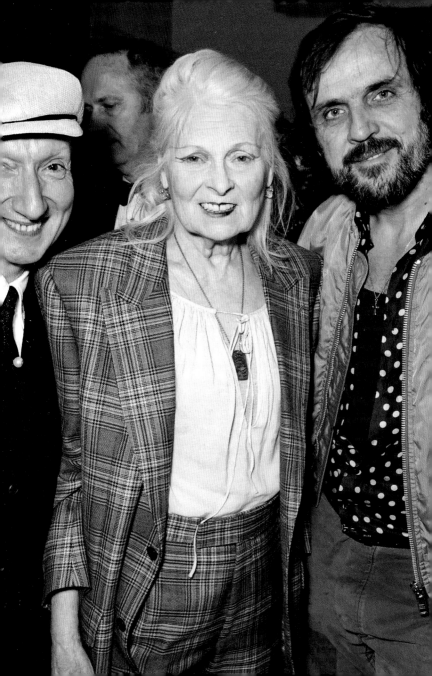

Index

Credits

The publishers would like to thank the following sources for their kind permission to reproduce the pictures in this book.

Alamy Stock Photo: Abaca Press 90-91; /Everett Collection Inc 142; /Goddard Archive Portraits 54; /Independent 93; /Jeremy Sutton-Hibbert 6; /MediaWorldImages 114; /PA Images 75, 80; /PictureLux/The Hollywood Archive 88; /Sport in Pictures 94; /Stockeurope 66; /Lee Thomas 121; /Mark Thomas 145; /V&A Images 77; /Vuk Valcic 144; /Zuma Press, Inc. 126

Camera Press: Photograph by Clive Arrowsmith, Camera Press London: 56

Getty Images: Jorgen Angel/Redferns 32; /Vanni Bassetti 151; /Dave Benett 73, 81, 110, 134, 153; /Stephane Cardinale/Corbis 98; /Gareth Cattermole 108; /Stefen Chow 82-83; /Richard Corkery/NY Daily News Archive 141; /Goffredo di Crollalanza/FilmMagic 89; /Arnal/Garcia/Gamma-Rapho 71, 79; /David Corio/Redferns 40, 42, 47; /Daily Mirror/Mirrorpix 25, 30; /Daily Mirror/Bill Kennedy/Mirrorpix/Mirrorpix 16-17; /Estrop 115; /Tristan Fewings 104; /Julian Finney 96; /Fox Photos/Hulton Archive 14; /Gotham/GC Images 138; /Dave Hogan/Hulton Archive 97; /Ian Gavan 9; /Andy Hosie/Daily Mirror/Mirrorpix 51; /Derek Hudson 86; /Indianapolis Museum of Art 63; /Foc Kan/WireImage 69; /Patrick Kovarik/AFP 101; /Pascal Le Segretain 146; /Mike Marsland/WireImage 122-123; /Michel Maurou/WWD/Penske Media 60, 61; /Leon Neal/AFP 102-103; /Tim Jenkins/Penske Media 29; /Matt Keeble/Dave Benett 154-155; /Duncan Raban/Popperfoto 72; /Peter Noble/Redferns 46; /Denis O'Regan 48-49; /Christopher Polk/Getty Images for NARAS 96; /John Phillips/Getty Images for BoF VOICES 127; /George Pimentel 139; /Eileen Polk 20; /Ki Price 118, 128-129, 131; /Michael Putland 59; /Julien de Rosa/AFP 150; /Nathan Shanahan/WireImage 136; /Matthew Sperzel 137; /Jeff Spicer 116; /John Stoddart/Popperfoto 8; /Allan Tannenbaum 23; /Victor Virgile/Gamma-Rapho 125, 147, 149; /Tim P. Whitby 120

Kerry Taylor Auctions: 27, 57, 64, 68

© Serpentine, Photography by Mark Blower: 111

Shutterstock: David Dagley 26; /Ian Dickson 24; /Nils Jorgensen 37, 119; /Sheridan Morley/News UK 76; /Graham Smith/Pymca 43; /Ted Polhemus/Pymca 45; /Domine-Marechal-Wyters/ABACA 100

Ray Stevenson: 33, 35, 36

University of Westminster Archives: 12

Every effort has been made to acknowledge correctly and contact the source and/or copyright holder of each picture any unintentional errors or omissions will be corrected in future editions of this book.